EXMOOR

THROUGH TIME

Steve Wallis

AMBERLEY PUBLISHING

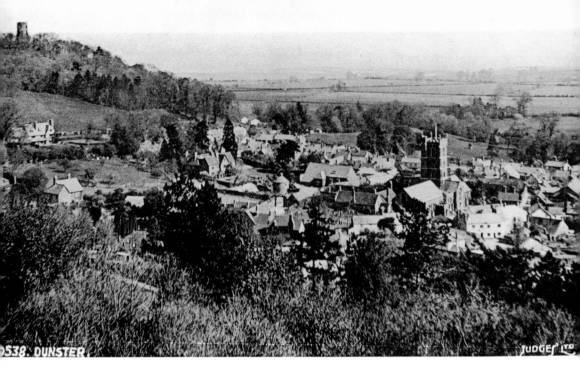

Dunster, general view from the west, *c.* 1925.

First published 2013

Amberley Publishing
The Hill, Stroud, Gloucestershire, GL5 4EP
www.amberley-books.com

Copyright © Steve Wallis, 2013

The right of Steve Wallis to be identified as the
Author of this work has been asserted in accordance with
the Copyrights, Designs and Patents Act 1988.

ISBN 978 1 4456 1651 3 (print)
ISBN 978 1 4456 1670 4 (ebook)

British Library Cataloguing in Publication Data.
A catalogue record for this book is available from the
British Library.

Typesetting by Amberley Publishing.
Printed in Great Britain.

Introduction

In common with the rest of the *Through Time* series, this book pairs old and new photographs of the same subjects to allow the reader to see how they have, or perhaps have not, changed. The old images belong, more or less, to the first few decades of the twentieth century. They generally come from postcards, which can be fascinating themselves in the subjects that have been chosen and the way they have been presented. I should add that the dates given for these images are estimates.

My photographs, which accompany the old ones, were all taken during August and September 2013. When taking them, I tried to use the same location as the previous photographer. Various factors prevented this in some cases – a need to keep to public rights of way, a view now blocked by housing or vegetation, or the belief that standing in a main road to take a photograph is unwise considering modern traffic levels. In such instances, I got as close as possible while still getting a reasonable view of the subject.

When I started on this book, I wondered whether much would have changed over the past century or so. After all, Exmoor is a protected place – it was declared a National Park in 1954, and before then it was a remote area, much of which was a royal hunting forest, where there was no great pressure for development. In reality, I found quite a few changes to buildings (the impact in Lynmouth of the devastating flood of 1952 and the works that were undertaken afterwards to prevent a repeat being an extreme example), but even more in the landscape. You will see that many of the old views here are now lost in the sense of being obscured by vegetation – often I have had to shift my location from that of the original photographer to get a view, while in some cases I have shown the same viewpoint, and then taken a picture of the subject from a completely different angle so you can see how it looks today. Some of this may be because the old photographer found

what was then a gap in a hedge or the like that does not exist today, but I also think it is because historically labour was cheaper and landowners could more easily get their workers to clear vegetation that they considered untidy, but which we might like for its attractiveness and nature conservation value. And perhaps even more because many people had to gather their own fuel, so that bracken, scrub and some trees were regularly harvested for this purpose.

I have taken as my subject area the present Exmoor National Park, of which 71 per cent is in Somerset, the remainder being in Devon. Individual chapters of this book look at particular areas of Exmoor, beginning at Lynton and Lynmouth and radiating outwards.

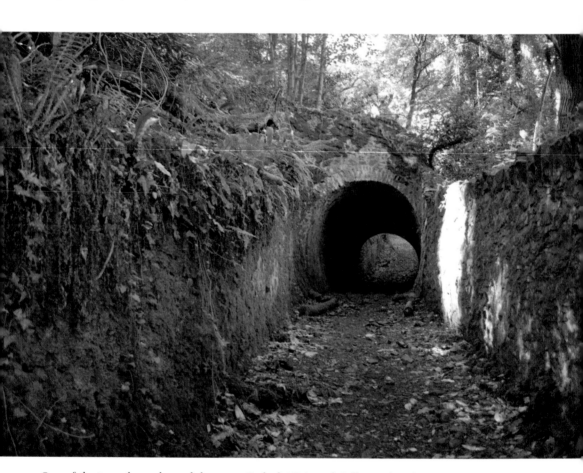

One of the tunnels on the path between Porlock Weir and Culbone church.

Lynton and Lynmouth

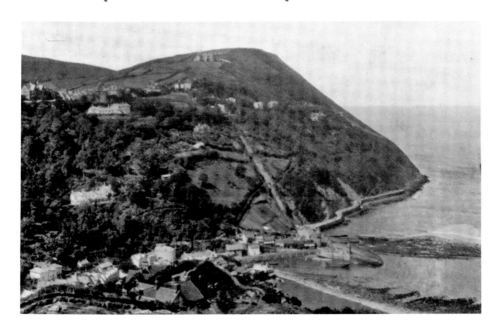

Lynton and Lynmouth, c. 1905

We start with what is arguably the most popular and visited location within the National Park, the 'twin towns' of Lynton on its hilltop and Lynmouth by the harbour below. The historic photograph in particular illustrates the relationship between the two very well, and also shows the local landscape, spectacular even by Exmoor standards. It was the scenery of this stretch of coast, together with the gorges inland, that attracted poets and others of the Romantic Movement such as William Wordsworth, Samuel Taylor Coleridge and Percy Bysshe Shelley in the early nineteenth century. Their accounts of the locality attracted others, and helped to change Lynton and Lynmouth from quiet villages into a booming holiday resort.

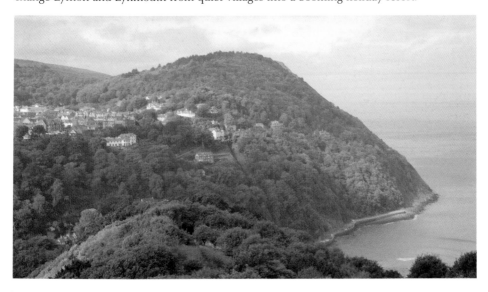

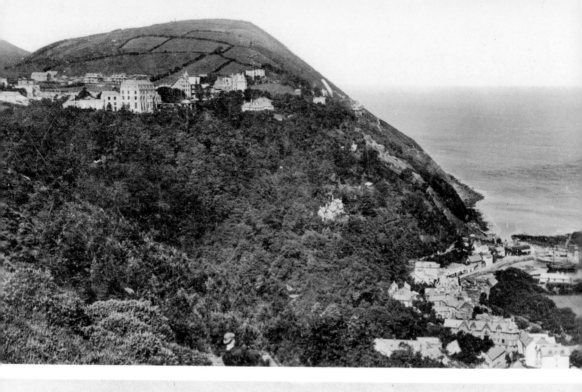

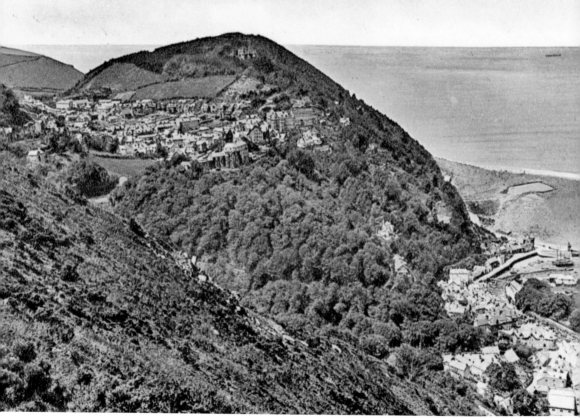

Lynton, Viewed from Summerhouse Hill, *c.* **1905 and** *c.* **1935**

We now move across to Summer House Hill on the southern side of Lynmouth for three views of Lynton. These were taken not only at different times but also from different locations on the hillside. Nevertheless, the expansion of the place over this period is evident. Beyond the town is Hollerday Hill, from which there are spectacular views not only back east to Lynton and Lynmouth, but also westwards to the Valley of Rocks and beyond. This vantage point was the site of a hillfort during the Iron Age. Comparing my photograph with the earlier ones shows how trees and other vegetation have spread over Hollerday Hill.

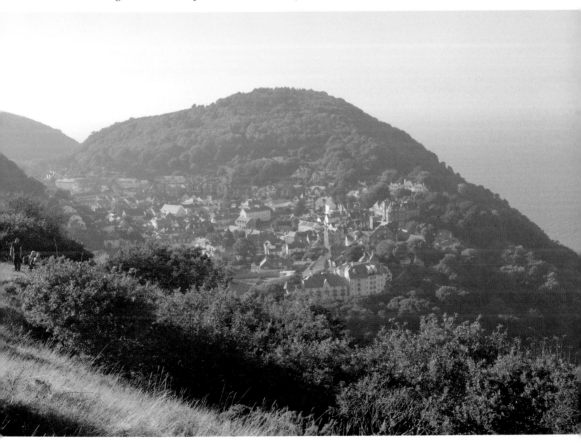

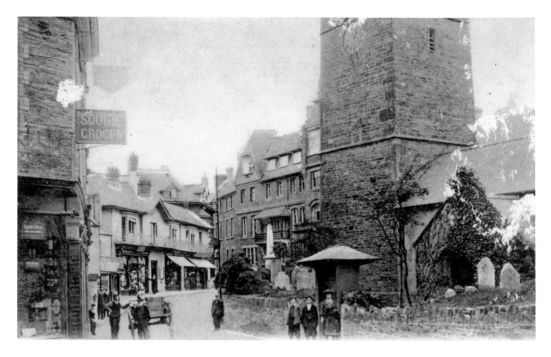

Lynton, Historic Centre, *c.* **1900**

We head across to Lynton, into what was the old village before the resort developed. On the right is St Mary's parish church, much changed by the Victorians but containing stonework dating back to the thirteenth century. Behind and to the left and seen better in the old view is one of the early features of the new resort, the Valley of Rocks Hotel, built in 1888.

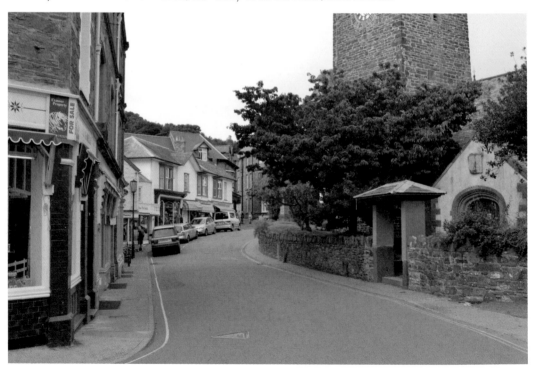

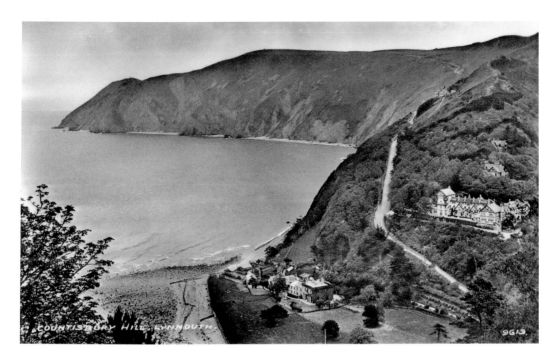

Lynton, View from the Westerway, *c.* 1930

Take the side road between the parish church and the Valley of Rocks Hotel and it leads you to the Westerway, the original and steep path that links Lynton and Lynmouth. Before construction of the road between the two settlements in 1828, the Westerway was the only route for transport to bring goods up to Lynton. It remains popular among visitors today – more so among those going downward. From the Westerway we get this view back across the Bay to Foreland Point.

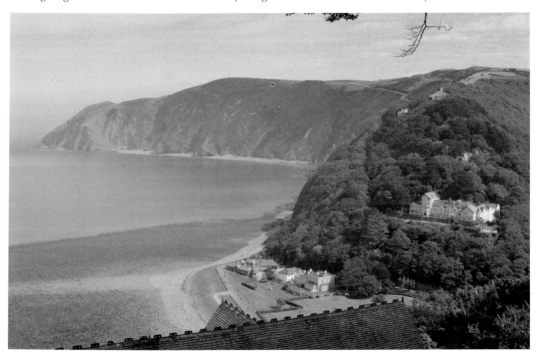

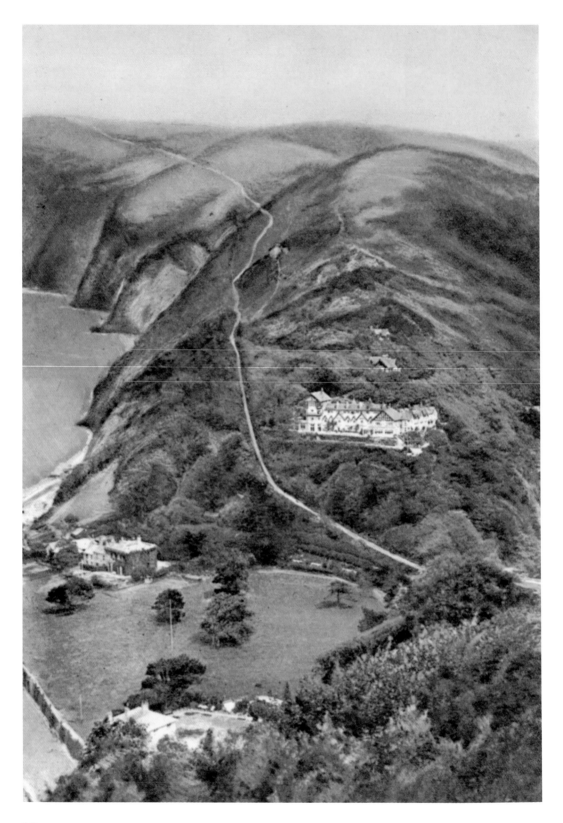

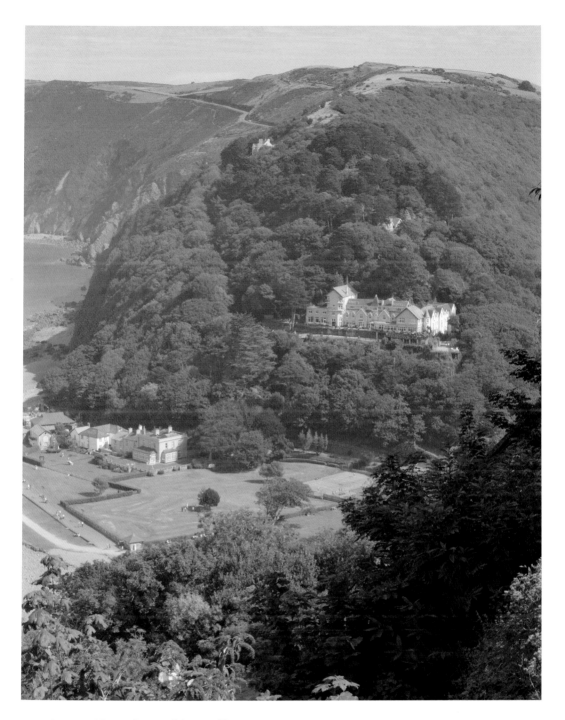

Lynton, View of Countisbury Hill, *c.* 1925
Here is almost a detail of the previous picture, showing the road snaking up the far hillside. The road is called Countisbury Hill because of the hamlet of that name at the top, although the Ordnance Survey calls the hill itself Wind Hill. The first pair of images in this book was taken from that hilltop. On the hillside we see the spectacularly located Tors Hotel, and the Manor House at lower left.

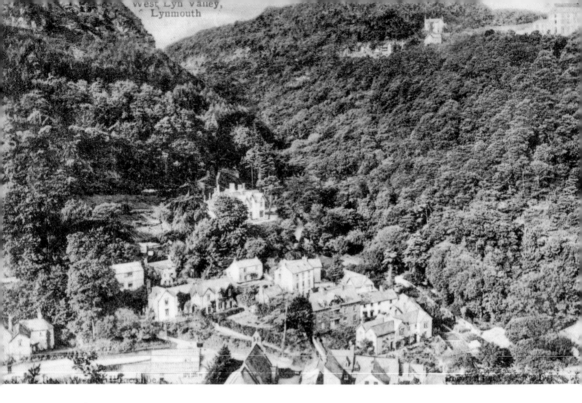

West Lyn Valley,
Lynmouth

Lynmouth, West Lyn Valley, c. 1900

We next head across to a path that goes up the south side of Wind Hill to get our first clear view of Lynmouth itself. As my first picture shows, it is difficult to see this view today because of foliage, and I have included another photograph taken lower down the hill. The old photograph is entitled 'West Lyn Valley', which is the feature running diagonally from top left to bottom right (more about that next). Below this is the eastern part of Lynmouth, most of which was first developed during the nineteenth century as the town became a tourist destination. The old view also shows the edge of Lynton high up on the right, and by comparing it with my first photograph, you get an impression of how the 'other town' has spread across the hilltop in the past century.

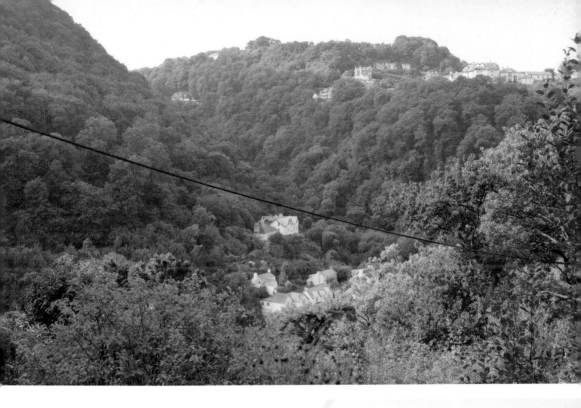

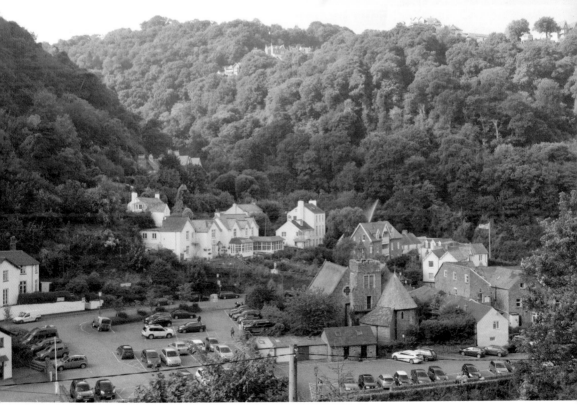

13

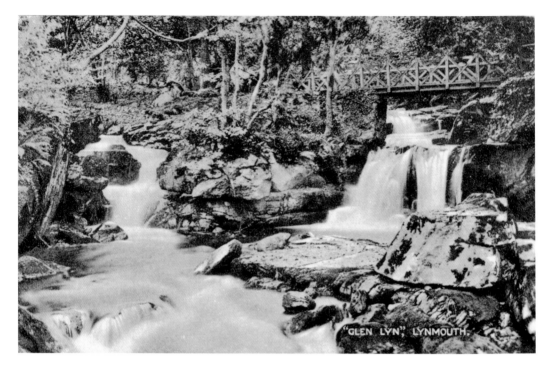

Lynmouth, Glen Lyn Gorge, c. 1925

The main river that flows through Lynmouth, and which cut the spectacular gorge in which Lynmouth sits, is the East Lyn. At Lynmouth, it is joined by the shorter and smaller West Lyn River, which cuts through the Glen Lyn Gorge as it approaches the confluence. The section of the latter at Lynmouth is now one of the town's tourist attractions. My viewpoint here was the adjacent road bridge, and I believe the old picture was taken from a similar spot.

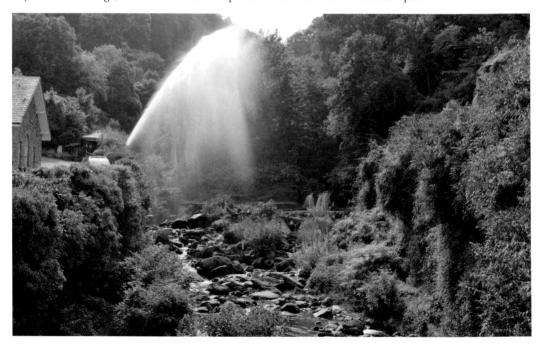

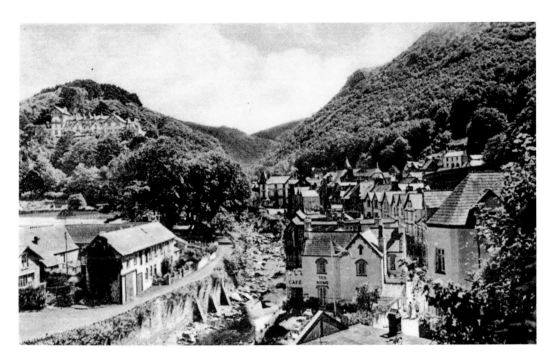

Lynmouth, Eastern Side and the East Lyn River, *c.* 1930

As well as making good the damage after the 1952 flood and ensuring nothing so catastrophic could ever happen again, the authorities also took the opportunity for some general improvements to Lynmouth and Lynton. One result was change to the road system between the two. We see a new section of road in the foreground of my shot, and while it is of great practical value, the road's presence makes it difficult for us to see other changes in the part of Lynmouth shown in the old picture.

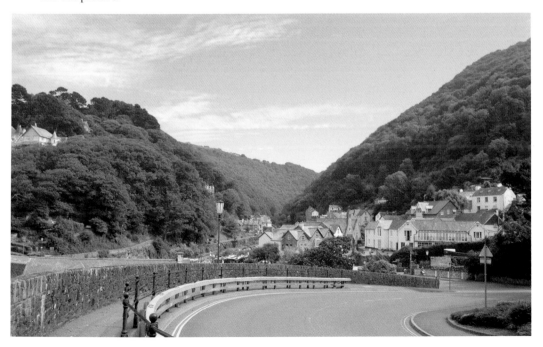

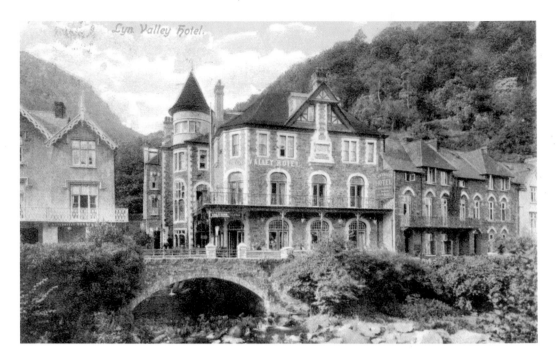

Lynmouth, Lyn Valley Hotel, *c.* 1900

We see much more graphic evidence of the flood and the redevelopment in its aftermath here. We look from the opposite side of the East Lyn River to see the West Lyn flowing in – my viewpoint in the previous view was the further of the two bridges. After the flood, the West Lyn was widened to ease the flow rate of any floodwater, so the replacement bridge carrying Riverside Walk had to be longer. Even more dramatically, the buildings on either side of the bridge have gone, including on the right the old Lyn Valley Hotel and some of the terrace next to it.

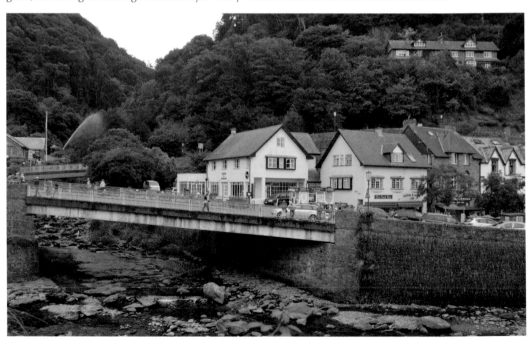

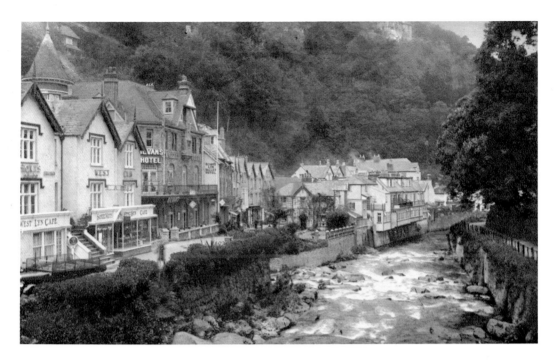

Lynmouth, Riverside Road, *c.* 1935
A more recent old picture illustrates the impact from a different angle. The old bridge over the mouth of the West Lyn is hidden from view here, but the building on the left is the same as that in this location in the previous old shot. Next to it, the Lyn Valley Hotel seems to have been renamed as Bevan's Hotel or something similar. Comparing the old and modern pictures, you can see other changes further along the road, and that the East Lyn has also been widened.

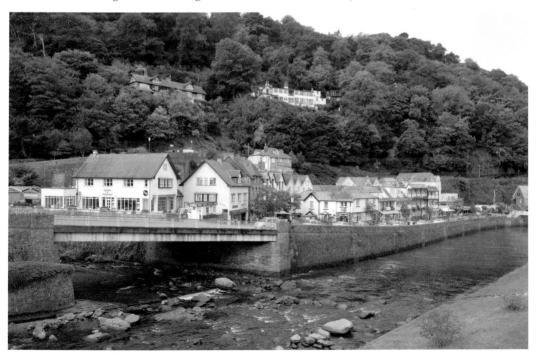

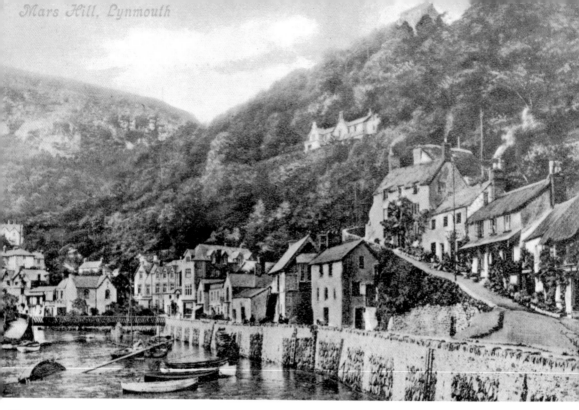

Mars Hill, Lynmouth

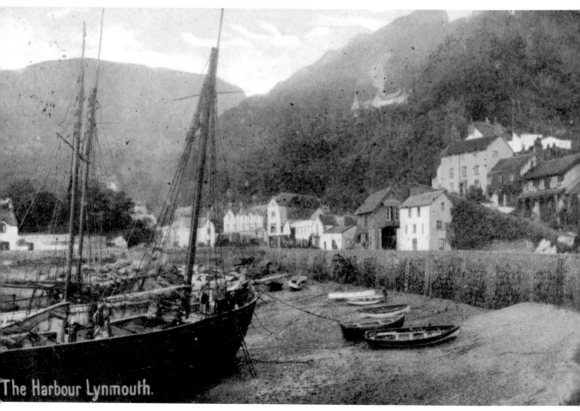

The Harbour Lynmouth.

18

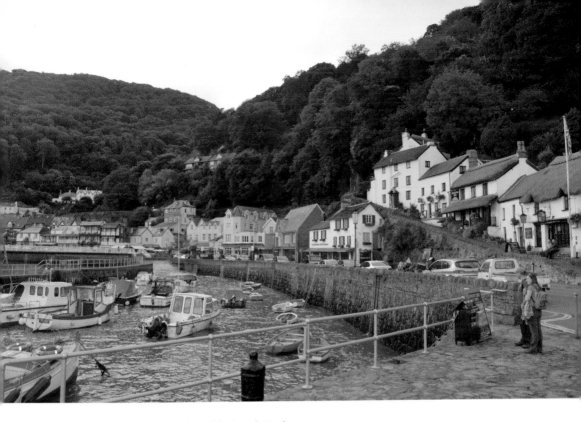

Lynmouth, View Along Riverside Road, Both c. 1900

I have put these two old views together because they show a similar subject. Their viewpoints were close together on the harbour wall at the far end of Riverside Road (or Lynmouth Street as it is sometimes called). Many of the apparent differences between them are the result of the artificial colouring that was done on some old postcards – those who coloured did not always take pains for accuracy, or may never have seen the original location! Nevertheless, there are real differences: one shows a high tide and depicts the harbourside buildings better – from Mars Hill on the right almost back to the Lyn Valley Hotel– and the other has low tide and shows more of the vessels that lay in the harbour. Compare both with my shot and you see some of the changes in the buildings and the vessels using the harbour over the past century.

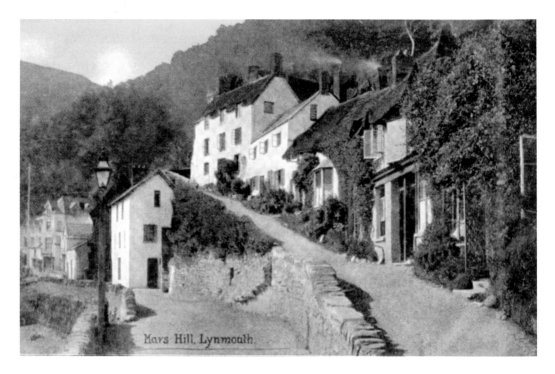

Mars Hill, Lynmouth.

Lynmouth, Mars Hill, c. 1905
Now for a closer view of Mars Hill. This little road is the bottom end of the Westerway that went up to Lynton. The cottages here give us the closest view of what Lynmouth looked like before it became a popular tourist destination. These properties date from the seventeenth and eighteenth centuries, and must have been the homes of fisherfolk and traders. Today, parts of several have been converted into the Rising Sun Hotel.

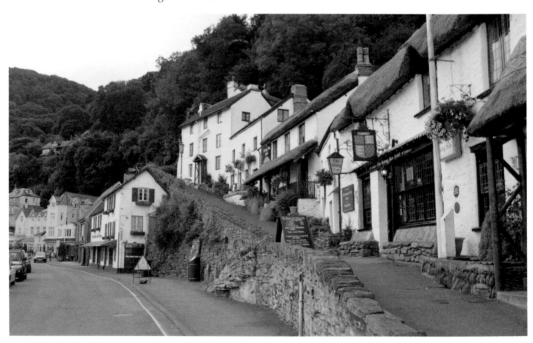

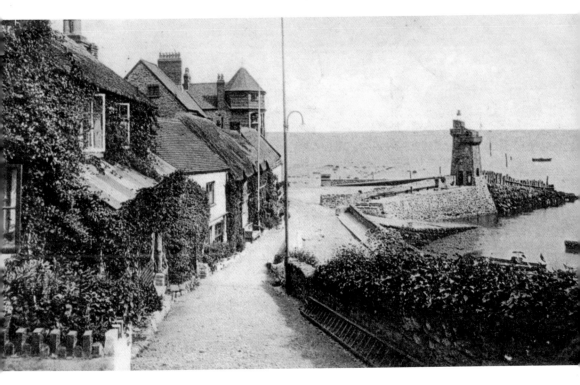

Lynmouth, View From Mars Hill, *c.* 1900

We head up Mars Hill past several of the cottages and turn around for this view towards the harbour wall. At the end of the row on our left we see a tower. This four-storey building is on the corner of Riverside Road and The Esplanade, and today houses a business called Aladdin's Cave.

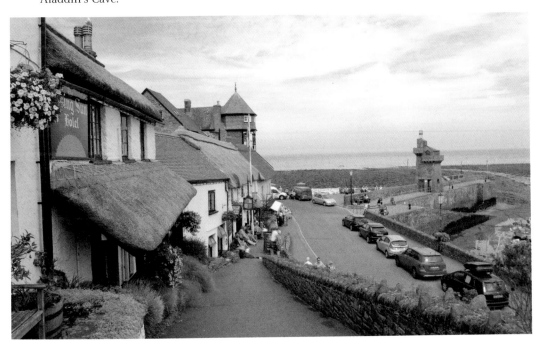

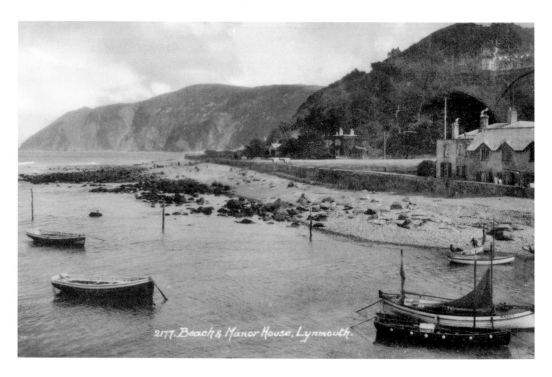

2177. Beach & Manor House, Lynmouth.

Lynmouth, Rocks House and Manor House, *c.* 1930

At the same viewpoint, we simply turn right through 90 degrees to look across the harbour. On the right is Rocks House, today a hotel and restaurant, which has two very different ranges, one built soon after the other in the earlier nineteenth century. Above it on the hillside we see The Tors Hotel again. In the middle distance is the 200-year-old Manor House and its outbuildings.

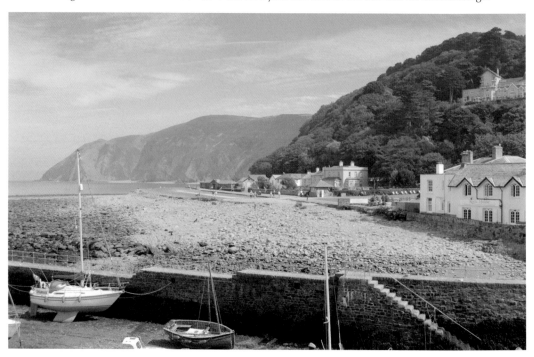

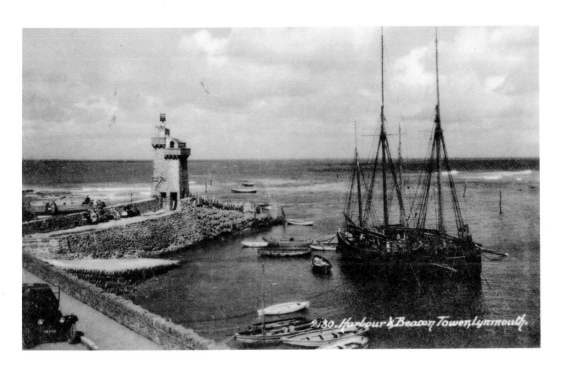

Lynmouth, Rhenish Tower, c. 1925

Now for a closer look at the harbour wall and the structure on it. The harbour wall was built around 200 years ago, and around the middle of the nineteenth century the tower was built upon it. Apparently, the exact reason for the latter's construction is not known – it may have been a folly, or could have been intended as a store for saltwater that was to be used in some indoor baths. Because of its German style, it is called the Rhenish Tower. It and the harbour wall were all but demolished by the 1952 flood and had to be rebuilt afterwards. The wall was also increased in size, and an additional wall was built on the other side of the harbour.

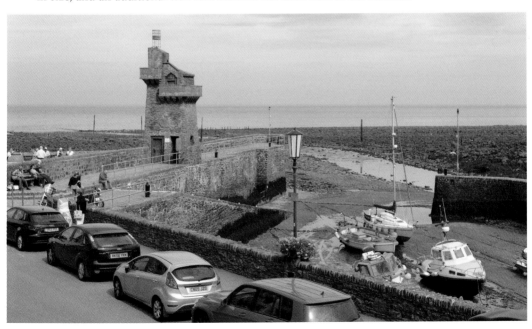

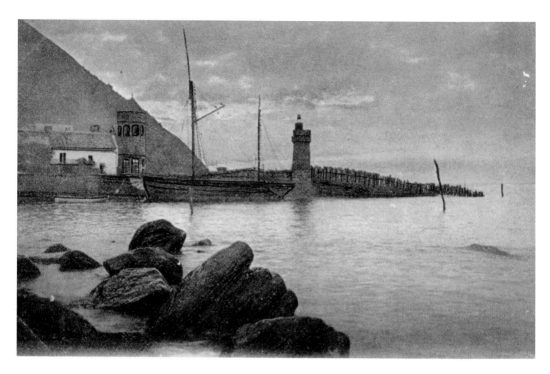

Lynmouth, Sunset Behind the Harbour, _c._ 1900
We head across to the other side of the harbour for another view. My photograph may not have been taken at quite such a romantic time of day, but it does show the greater size of the harbour wall after its rebuilding, as well as the new riverside wall.

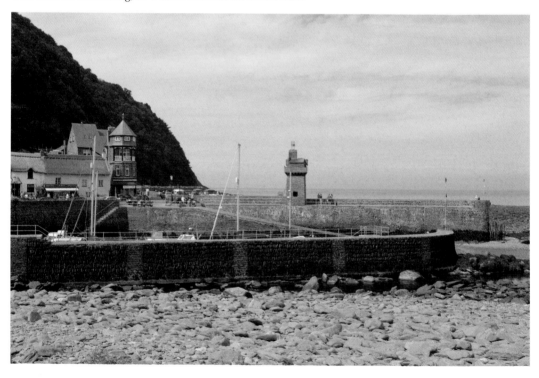

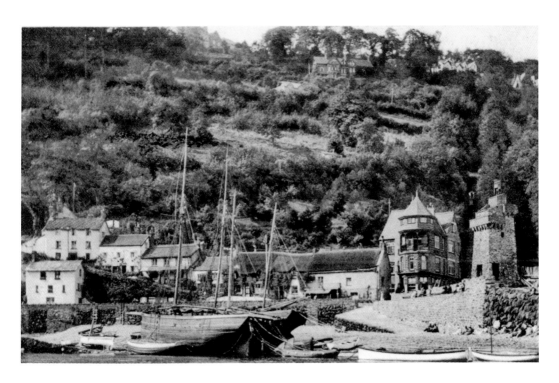

Lynmouth, View from the Beach, c. 1920
Going further out, we get this fine old view back from the beach that extends from the cottages of Mars Hill to the harbour wall and its tower, with a sailing ship as a bonus. The line of the Cliff Railway can be made out just left of the tower. Comparison between this and my photograph shows how vegetation has spread across the hillside.

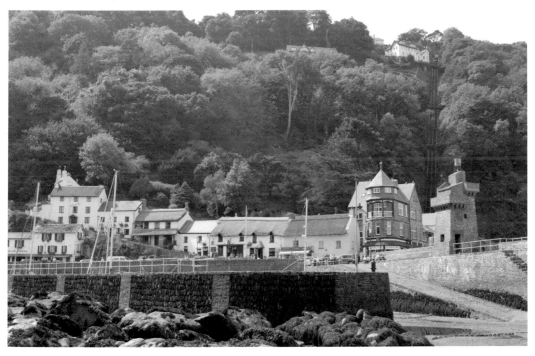

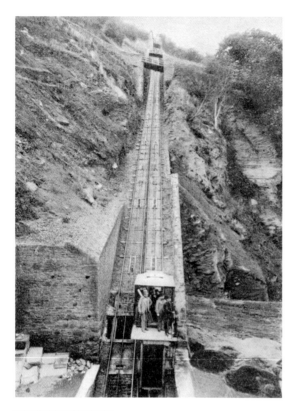

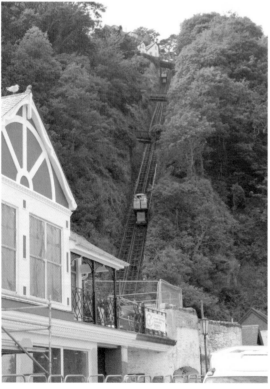

Lynmouth, The Lynton & Lynmouth Cliff Railway, *c.* 1905

Now round into the Esplanade for a look at the Cliff Railway, which we have seen from a distance before. As those who have climbed the Westerway will know, it had always been difficult to transport goods from the harbour at Lynmouth up to the village of Lynton, and as more and more tourists came to the area (needing to be fed as well and complaining about the climb), the problem was exacerbated. The solution came with the Lynton & Lynmouth Cliff Railway, funded largely by Sir George Newnes, a local benefactor, and designed by George Croydon Marks. Construction began in 1887; the railway opened on Easter Monday in 1890 and it has been operating ever since.

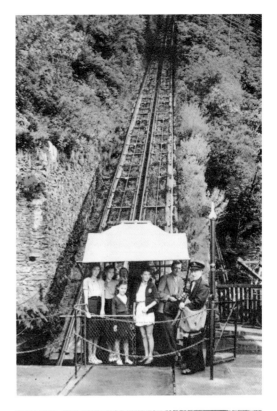

Lynmouth, How the Railway Works, c. 1935

The Cliff Railway is described technically as a water-powered funicular railway. There are two railway cars, attached by a cable, that have to travel at the same time – one going up while the other is going down. Each car has a large water tank beneath the passenger cabin. The one at the top needs to be heavier than the one at the bottom – sometimes this is achieved by the number of passengers, otherwise the one at the bottom discharges some of the water from its tank – and when this is so, the drivers of both cars ease off the brakes, and gravity does the rest.

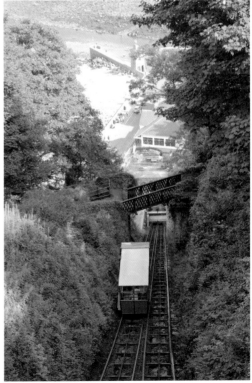

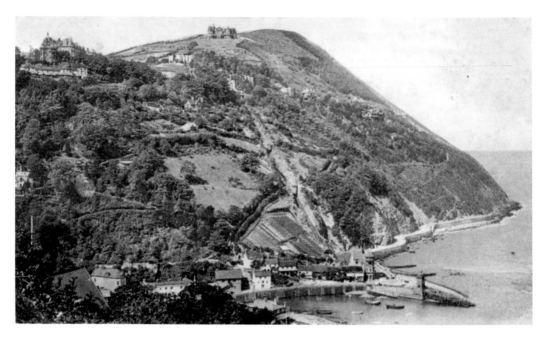

Lynton, Distant View of Hollerday House, *c.* 1900

Going back to Sir George Newnes now. The old picture gives an excellent view of the Cliff Railway cutting into the hillside. We also get a good look at Sir George's home, Hollerday House, which is very prominent on the hilltop above the railway. The house was built between 1891 and 1893, and burnt down in 1913, three years after Sir George's death. Today, only a few ruined walls survive in the woods, although the levelled area of Sir George's old tennis court is more easily recognised. My photograph here gives a wider view of the town than the similar photograph earlier.

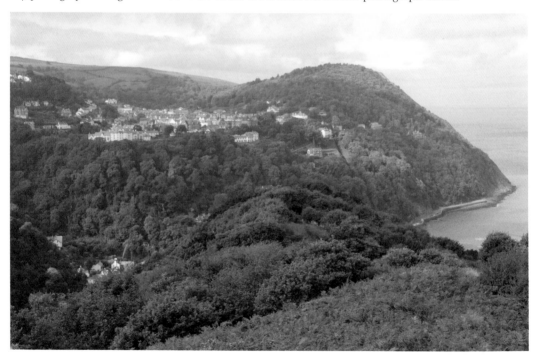

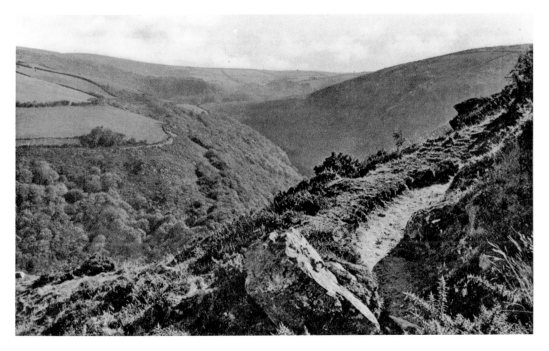

The East Lyn Valley, *c.* 1935

Several of our earlier views have indicated how wild the countryside is only a short distance from Lynton and Lynmouth. One of the best ways to appreciate this (provided you don't object to a steep climb) is to follow one of the paths that run from Lynmouth up Summer House Hill. In these shots, we are looking eastwards up the East Lyn Valley towards Wind Hill.

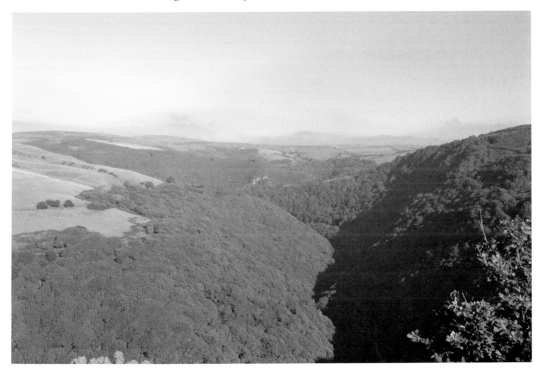

West of Lynton

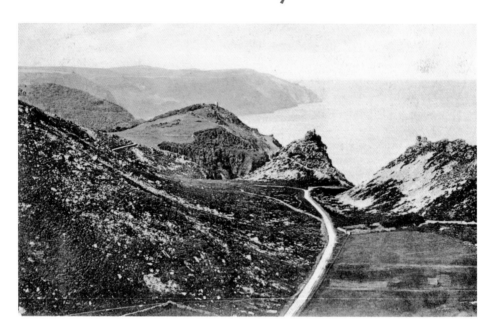

Valley of Rocks, Wide View, c. 1910

In this chapter, we head westwards mainly along the coast, and start only a short way outside Lynton, although the view looks much more remote. The viewpoint is on the west side of Hollerday Hill, and we are looking at the Valley of Rocks, a former course of the East Lyn River through some particularly ancient stone. The hill to the right is called Ragged Jack, and the more conical one next to it is Castle Rock; then comes Duty Point, on which you can just make out Duty Point Tower, a nineteenth-century folly in the grounds of Lee Abbey.

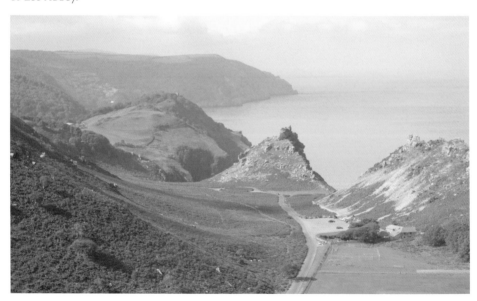

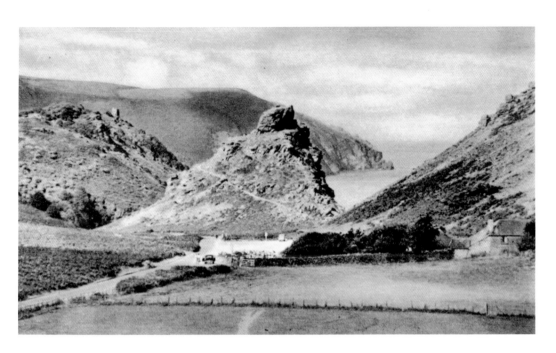

Valley of Rocks, Mother Meldrum and the Cricket Club, *c.* 1930

Dropping down Hollerday Hill, we get a closer view. The old shot was taken a couple of decades after the previous one, and comparing them you can see that the car park has now appeared. Today, the building next to it is Mother Meldrum's Tea Gardens and Restaurant, named after a local witch-cum-wise-woman of the Middle Ages with whom a nearby cave is associated. In the foreground is the ground of the Lynton & Lynmouth Cricket Club, widely recognised as having one of the best locations in the country.

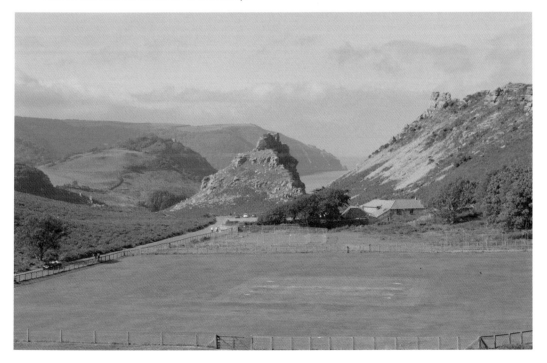

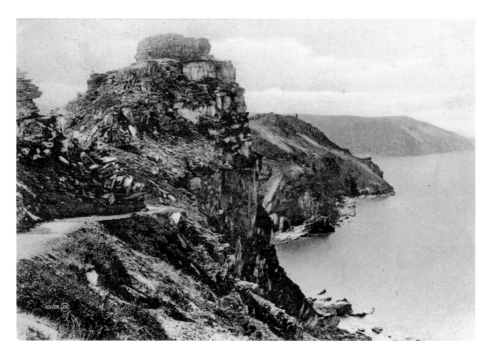

Valley of Rocks, Castle Rock, *c.* 1905
Now we head around to the other side of Ragged Jack to the section of the coastal path that cuts into its steep side. Today, this is part of the South West Coast Path. We are looking over at Castle Rock, beyond which is Duty Point with its tower and then the west side of Woody Bay.

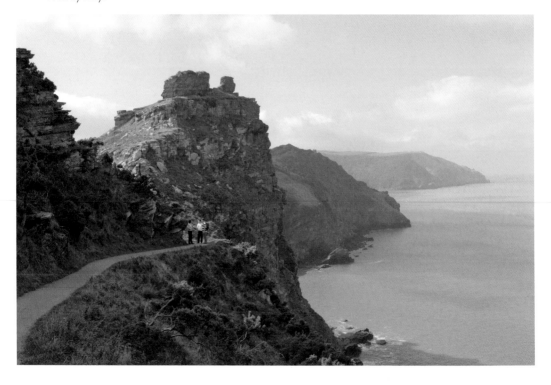

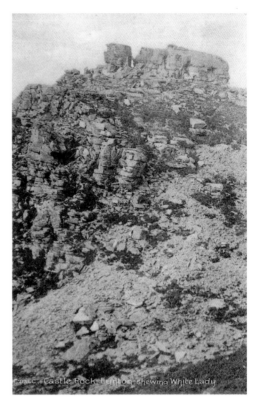

Valley of Rocks, White Lady, *c.* **1910**
Now for a rather clever illusion (so clever, in fact, that I didn't notice it and took my photograph in the wrong spot). If you go around to the south side of Castle Rock and stand in exactly the right location, as the early photographer did very successfully, then look up at the rocks standing out at the top of the hill, you see what looks like the silhouette of a white lady. She is in the gap between the almost separate block of stone on the left and the main mass.

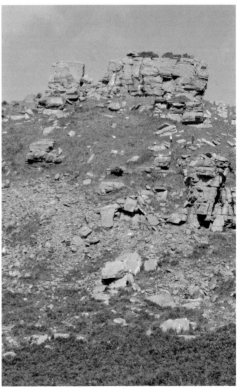

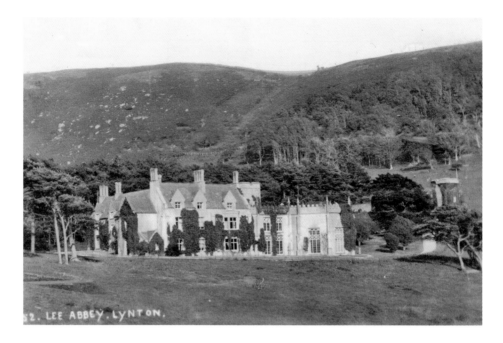

Lee Abbey, *c.* 1920

The road that runs through the Valley of Rocks continues westward along the coast, and for some of its course doubles up as the South West Coast Path. About a mile along, it passes Lee Abbey. The building was never a real abbey – it was built around 1850 in the Gothic style, incorporating an earlier manor house. A Christian organisation took it over in 1945, and it has since been a community and residential centre.

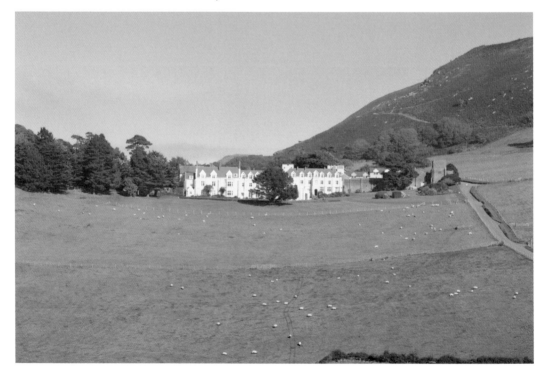

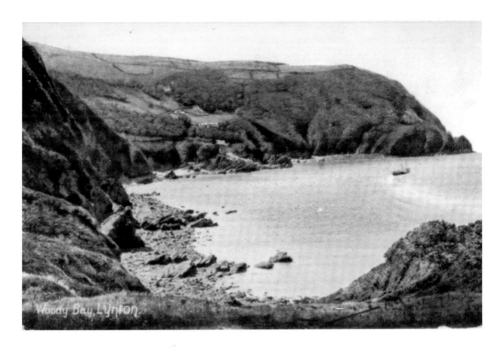

Woody Bay, General View, *c.* 1910

A mile further west, we reach Woody Bay, which lives up to its name with steep, wooded slopes dropping down to a rocky shore. It is surprising to learn that there were plans to construct a major holiday resort here in Victorian times. In 1885, a Colonel Lake bought the local manor and began a development that was to include hotels, a golf course, a pier and a station on a narrow gauge railway between Lynton and Barnstaple. There was rivalry from the established resort at Lynton and Lynmouth; the pier was damaged in a storm in 1899 and the following year Lake went bankrupt. My picture is taken from the west side of the bay and shows some of the villas that were built in Lake's time.

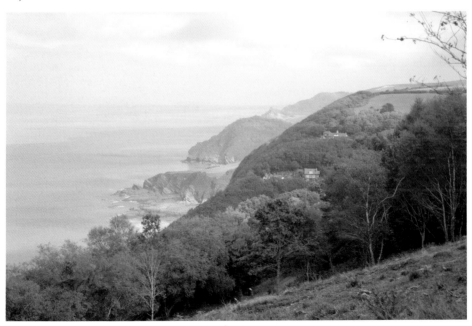

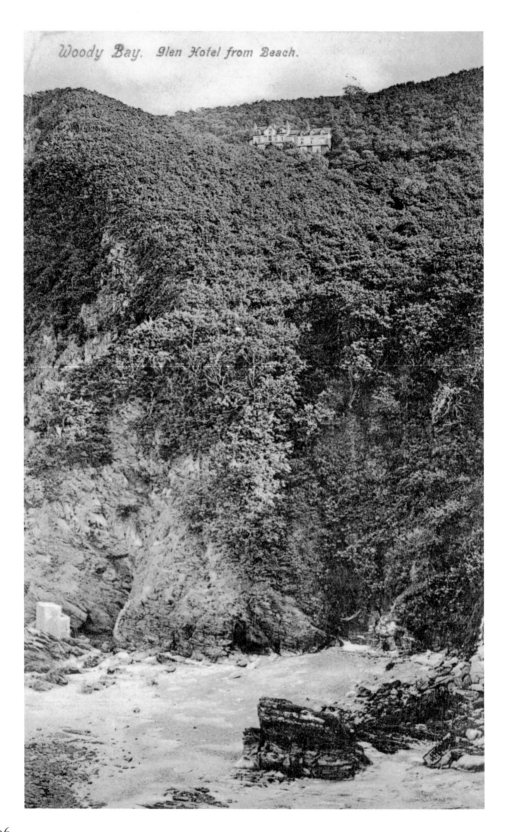

Woody Bay. Glen Hotel from Beach.

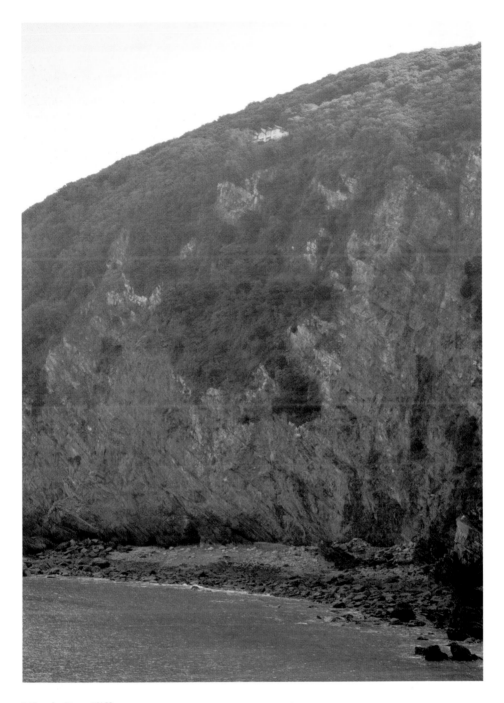

Woody Bay, Cliffs, *c.* 1905

The old picture here is a great illustration of just how high and spectacular the cliffs of this part of Devon are. It was taken from the beach when the tide must have been low, and shows a section of the south-eastern side of the surrounding cliff. The building at the top, which acts nicely as a scale for the view, is called the Glen Hotel in that image. Today I believe it is called The Pines. I visited when the tide was in and took my photograph from above the beach.

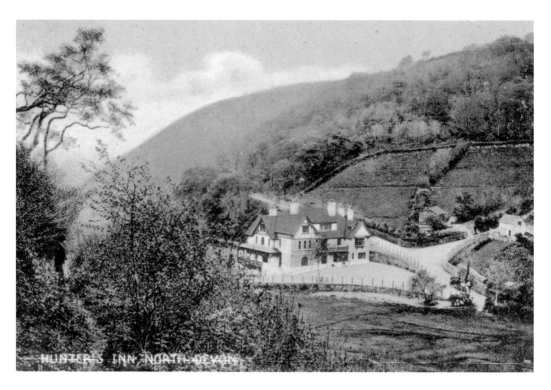

Hunter's Inn, *c.* 1910

A couple of miles west of Woody Bay as the crow flies, but rather further for those driving around the lanes, we find the Hunter's Inn at the bottom of the Heddon Valley. Today, it has the National Trust's Heddon Valley information centre and car park as neighbours.

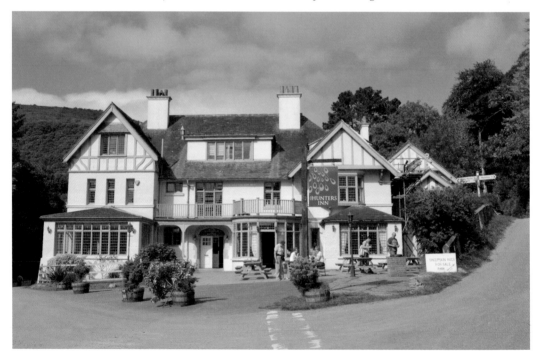

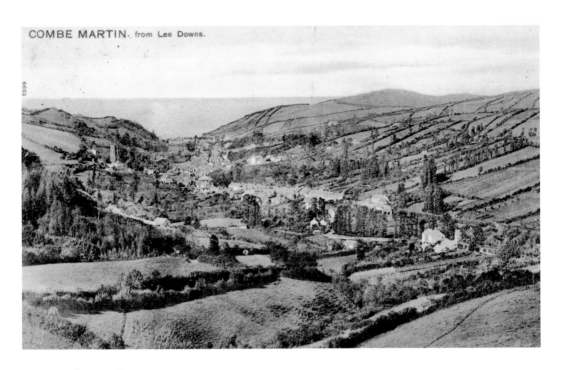

COMBE MARTIN. from Lee Downs.

Combe Martin, *c.* 1905

At its western extremity, the National Park ends at the deeply cut valley in which lies Combe Martin. This village stretches along the road that runs through the valley bottom about 3 miles east of Ilfracombe. These two photographs were taken from different viewpoints – mine from the road as it approaches the village from the south-east, the old one from further west. The tower of the parish church is prominent in both views, and the hills on the right side of the village are generally within the National Park.

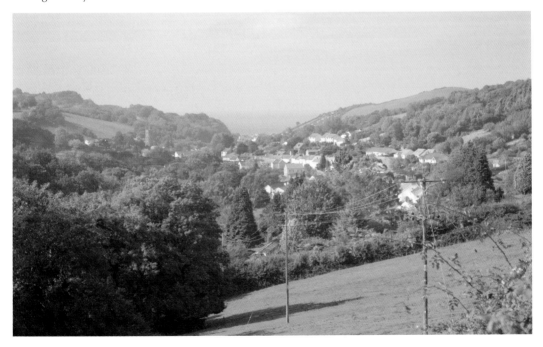

The Valleys of the East Lyn and its Tributaries

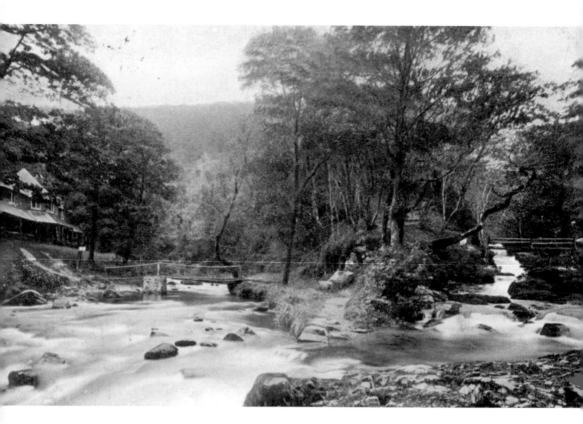

Watersmeet, c. 1905 and c. 1930

In this chapter, we follow the East Lyn River upstream and generally eastwards from Lynmouth. The river is also known as the Oare, particularly further upstream in the vicinity of the settlement of that name. Our first stopping point is about a mile from Lynmouth, where the river is passing through a deep gorge. This place is Watersmeet, recording that here the Hoar Oak Water flows into the East Lyn – the tributary is on the right in these views. The house we glimpse on the left was built in 1832 as a fishing lodge and retreat by a local landowner inspired by the Romantic poets, who came to the Lynton and Lynmouth area and extolled its virtues. It became a tea shop in 1901, and continued in this function when the National Trust acquired the land hereabouts in 1934. I have included two old images of this view, not only because they are both attractive, but also as the Edwardian one clearly shows a bridge crossing the East Lyn and the one taken a quarter of a century later does not. I would guess that at some point in between the taking of the two images, the bridge was damaged or demolished by flooding or some such, and that for a time visitors had to ford the river to reach the tea shop.

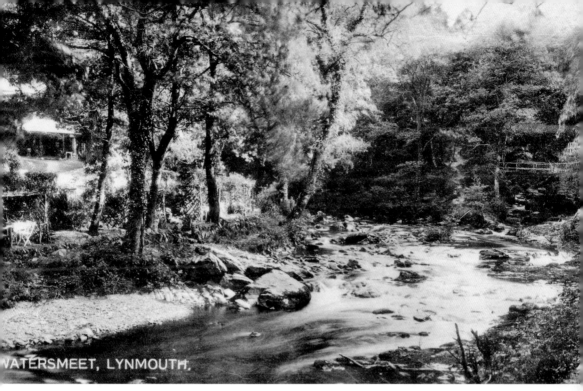

WATERSMEET, LYNMOUTH.

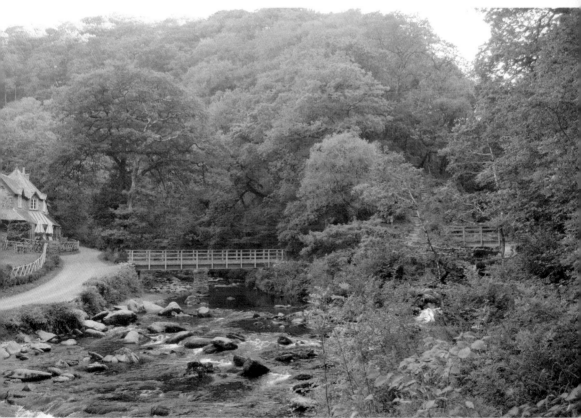

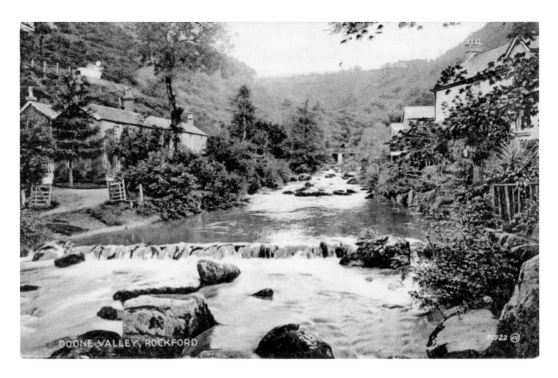

Rockford, Ford, *c.* 1910

We continue up the East Lyn River for a couple of miles to the western end of the village of Rockford. Here we find this ford, which seems to have had a weir beside it a century ago, but there are stepping stones today.

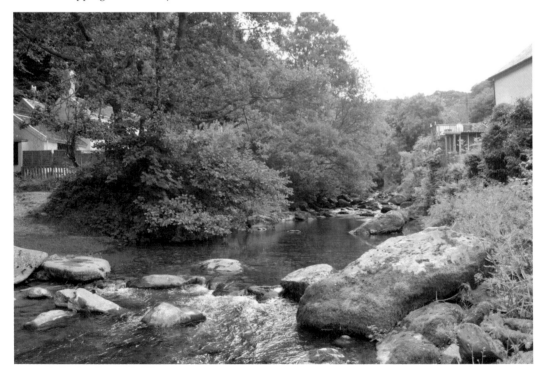

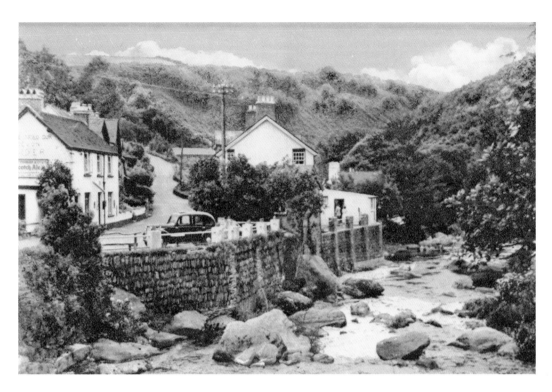

Rockford, Opposite View, *c.* 1935

Now we go upstream to the other side of this small village and look back from the footbridge on its south-east side. On the left, today almost hidden by vegetation, is the Rockford Inn, a coaching inn dating from the seventeenth century.

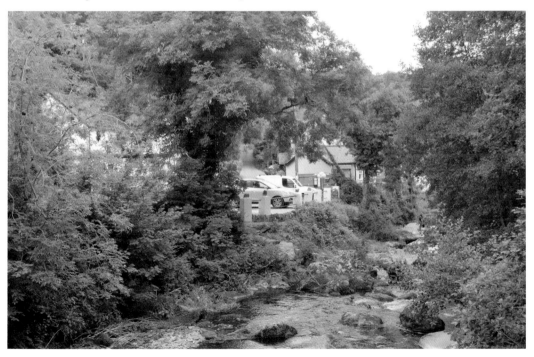

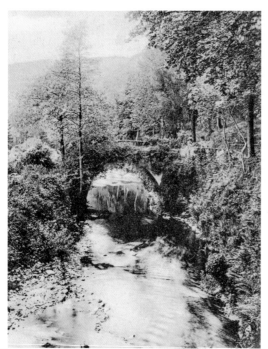

Brendon, Hidden Bridge, c. 1905

Another mile or so upstream we reach Brendon and the adjacent hamlet of Leeford. The old photographer was standing on the bridge that takes a side road across the East Lyn River and took this view downstream. His subject was a narrower footbridge, built in the seventeenth or eighteenth century, that served the old Brendon Mill on the south side of the river. As you can see, today the bridge is obscured by foliage, and I have included a view of it taken from the road on its north side.

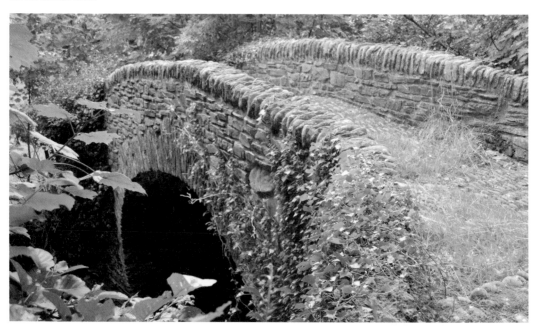

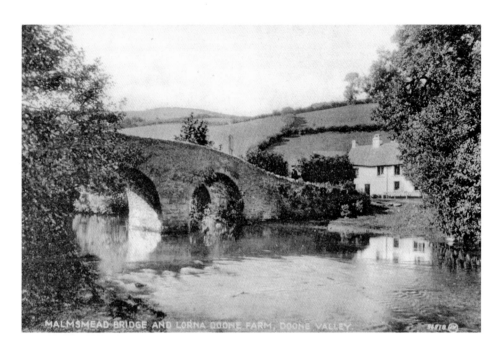

MALMSMEAD BRIDGE AND LORNA DOONE FARM, DOONE VALLEY

Malmsmead, Bridge and Lorna Doone Farm

Roughly 2 miles further on, the Badgworthy Water joins the river, and we now divert up that tributary. This takes us into what is called today the Doone Valley, since it was the main setting for Richard Doddridge Blackmore's famous novel *Lorna Doone*. It was published in 1869 but described action in the more lawless times of the late seventeenth century. A short distance on, we reach Malmsmead. For several miles, the Badgworthy is the county boundary between Devon and Somerset, and the viewpoint here is on the Somerset side. The narrow packhorse bridge (with a car crawling across in my picture) and the building beyond, which has been renamed Lorna Doone Farm, both date from the century in which the novel was set.

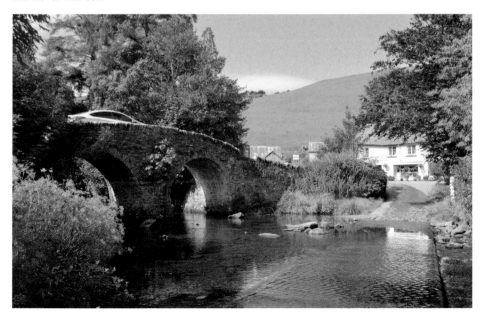

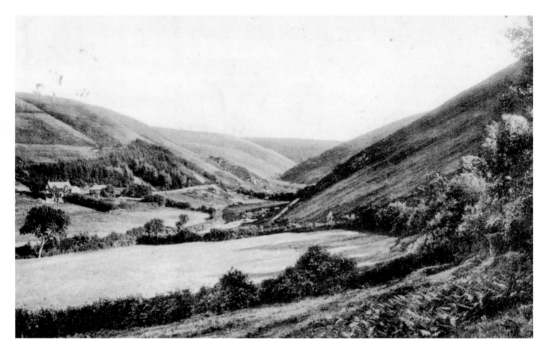

Doone Valley View, *c.* 1905
Next we look at two locations less than a mile south of Malmsmead, which illustrate the wilderness of the Badgworthy valley, making it such a fitting location for the novel, in which the Doone family who lived here were effectively a bunch of outlaws. This view looks south-east from the Devon side of the valley, with Cloud Farm over on the left.

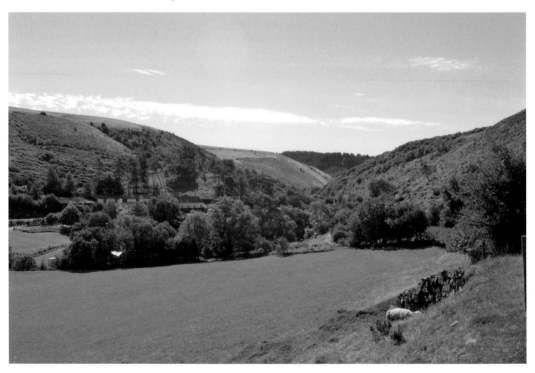

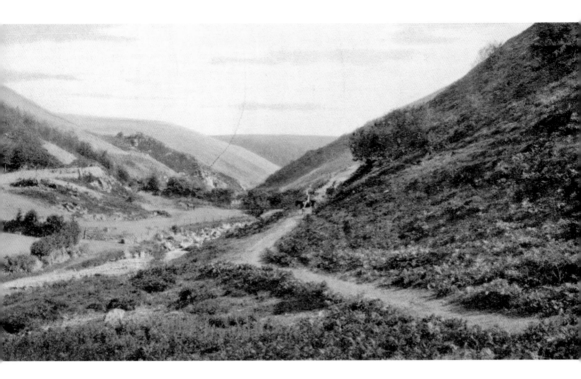

A Little Further On, *c.* 1905

At first glance, this old picture seems to be showing the same view as the previous one, but look on the left and you will see that there is no farm. It was actually taken from the same path and looking in the same direction, but from a few hundred yards further south, just past the bridge that crosses the river to Cloud Farm.

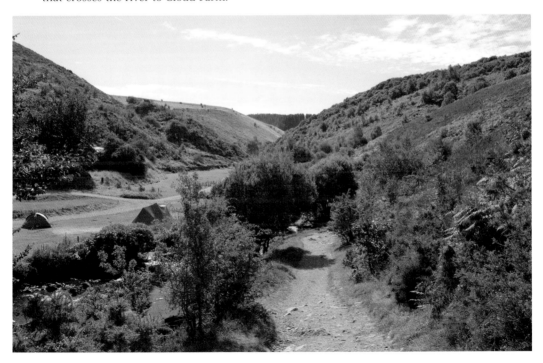

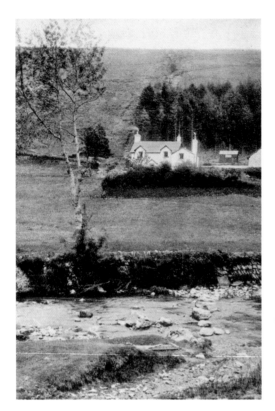

Doone Valley, Cloud Farm, *c.* **1920**
This old view is entitled 'Lorna's Bower, Doone Valley'. I believe it actually shows Cloud Farm, as seen from across the Badgworthy Water; if so, the farmhouse has been extended quite a lot since then.

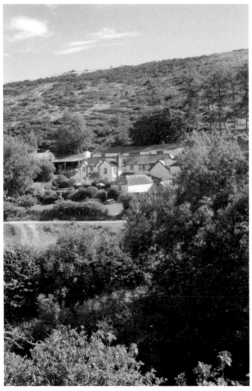

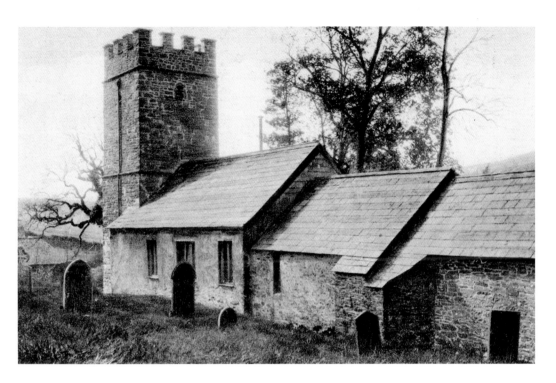

Oare, Parish Church, *c.* **1920**

Returning to the confluence, we continue up the valley of what is now definitely called the Oare Water, and after a short distance reach the hamlet of Oare itself. Much of the parish church, which is dedicated to St Mary, dates from the fifteenth century, and it has a lovely interior of wooden box pews and a pulpit. The church is also renowned as the location where Lorna Doone was shot.

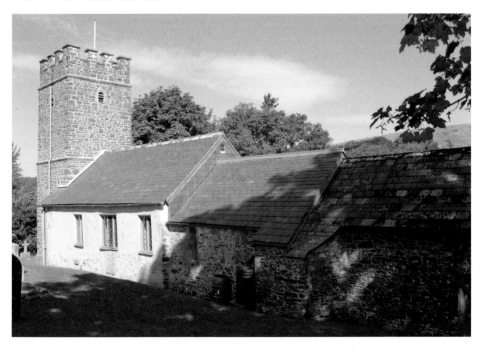

Robbers Bridge, *c.* **1930**

Further up the valley, several streams join the Oare Water, and the name of the stream in the valley bottom now becomes the Weir Water. A narrow road runs beside it from Oare, passing the tiny settlement of Oareford after a mile or so, then a short distance further on crossing the Weir Water by Robbers Bridge, which is linked to the Doone family in local legend. The old photographer has taken a footpath that runs north-east and uphill from the bridge over to the Culbone Inn on the A39 main road to get their location. You can see the bridge in shadow in the lower-middle part of the resulting image. From this point today, the bridge is obscured by trees, as can be seen in one of my photographs. The other is a much closer view of this eighteenth-century stone bridge, which is narrow even by the standards of Exmoor, so that wider vehicles presumably have to use the ford next to it. Past the bridge, the road winds its way steeply uphill, joining the main road on Porlock Hill.

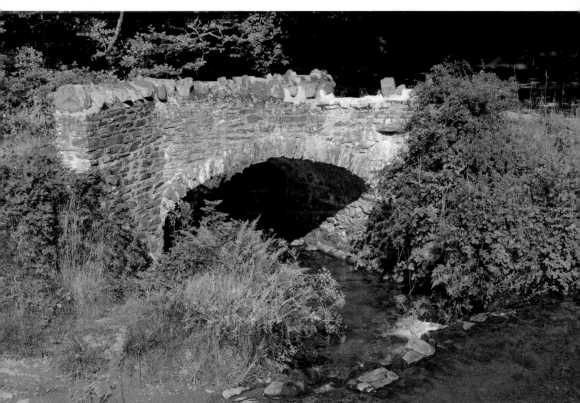

Porlock and Around

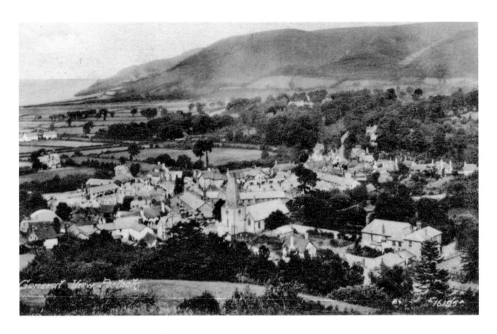

Porlock, View Across the Village, c. 1925

In this chapter, we continue east further into Somerset to look at a series of views in and around Porlock. Here we look across the historic centre of that village from the hillside to the south-west, with Bossington Hill and the coast in the background. Comparing the two views we get some idea of how much the village expanded during the twentieth century. The parish church occupies a prominent location in the old picture, and it is here that we will go next.

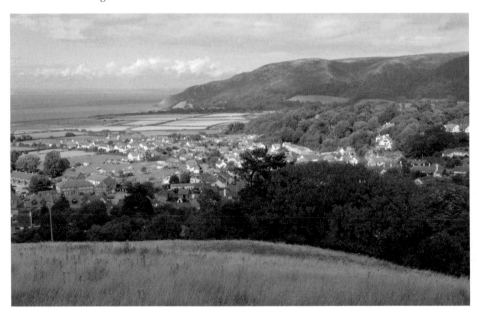

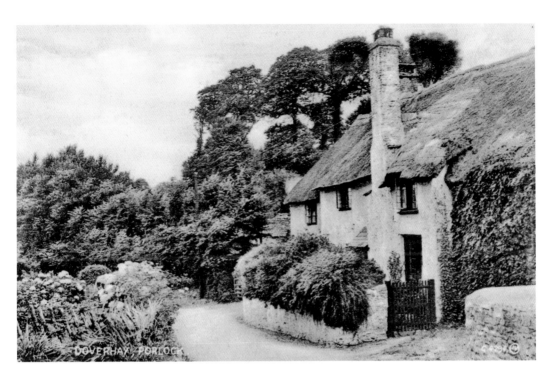

Porlock, Lower Doverhay House, *c.* 1935

A little way east of the church, a lane called Doverhay heads uphill. It is partway up here that we get this view. Today, the property has lost its thatched roof, the barn on the side has been cleared of ivy, and other houses have been built across the lane.

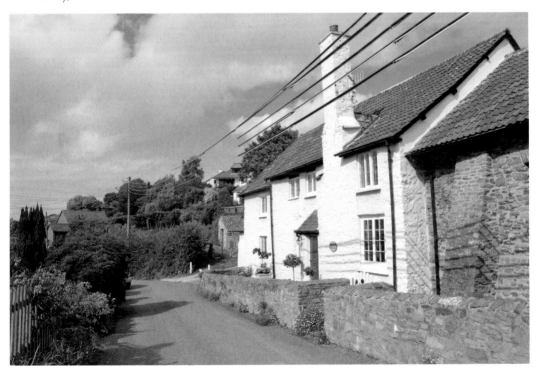

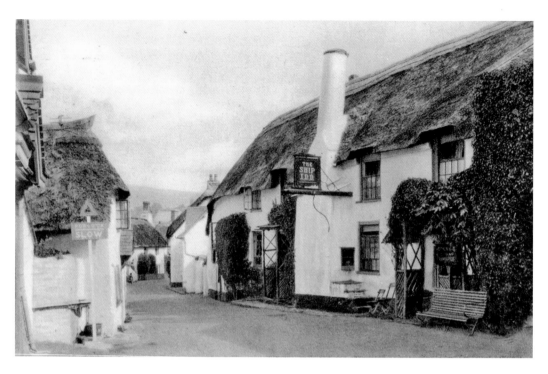

Porlock, The Ship Inn, *c.* 1935

Back west along the High Street and just round the bend onto Porlock Hill, we find The Ship Inn, sometimes known as The Top Ship to distinguish it from another Ship Inn down at Porlock Weir. This one dates from the seventeenth century.

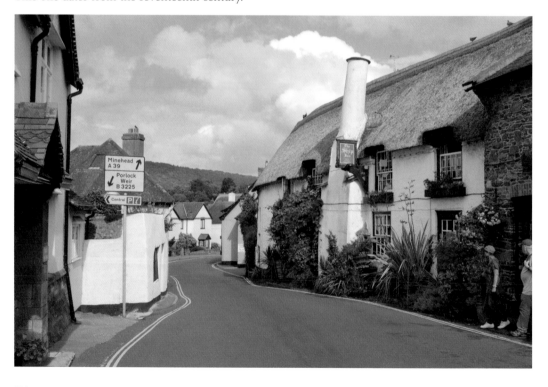

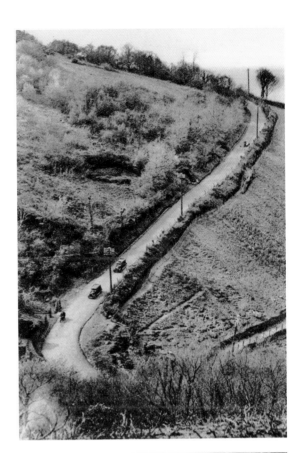

Porlock Hill, Porlock, c. 1930
This old photograph is a real lost view! It looks down on the section of the A39 coast road that climbs steeply and around some amazing bends on the west side of Porlock. The whole of the hillside here is now heavily wooded, and I took my picture from much further down near the last houses in Porlock.

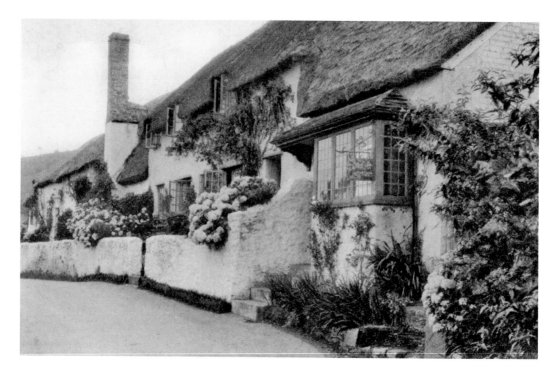

West Porlock, Cottages, c. 1930

Dropping back down Porlock Hill, we turn into the road to Porlock Weir. On the way, we pass through the hamlet of West Porlock and see these cottages at the far end on the south side of road. Although vegetation partly blocks the view today, it is clear that the cottages have changed quite a lot. For instance, the thatch has gone from the roofs – something often frowned upon nowadays, but thatch tended to leak rainwater and was expensive to maintain.

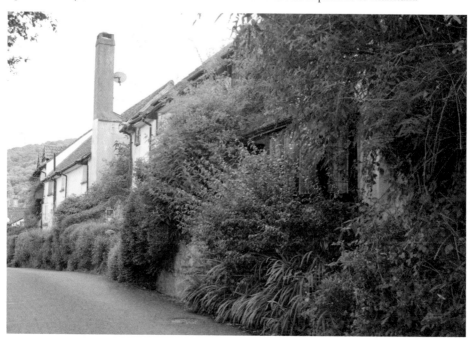

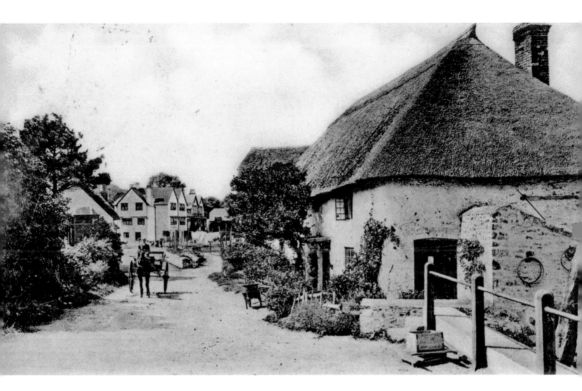

Porlock Weir, on the Way in, *c.* **1905**

Porlock lies about half a mile inland, and since the Middle Ages it has relied on the little harbour at Porlock Weir for access to the Bristol Channel. The viewpoint here is just as we come into the lovely little hamlet, with the Anchor Hotel down at the harbourside in the distance.

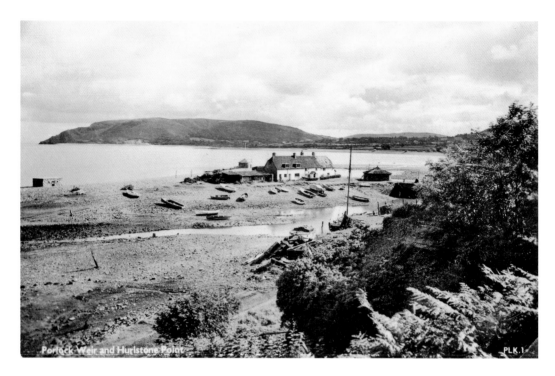

Porlock Weir and Hurlstone Point — PLK.1

Porlock Weir, Turkey Island, Early 1940s

We go through Porlock Weir and follow a footpath for a short distance to look back at the cottages on Turkey Island, on the west side of the harbour. Bossington Hill and Porlock are in the distance. The low structure on the beach to the left of the cottages is a pillbox, erected here as part of a coastal defence system during the early years of the Second World War, when there was a very real fear of German invasion.

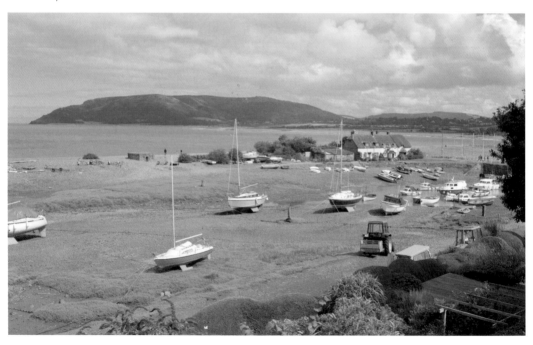

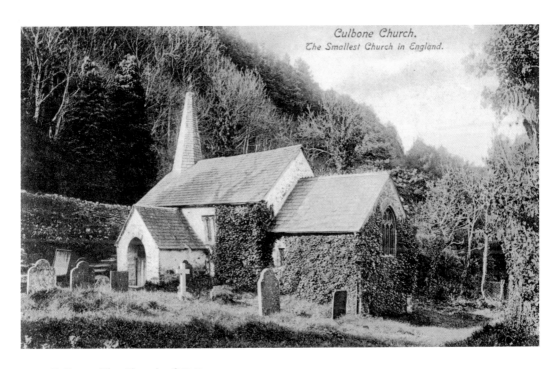

Culbone Church.
The Smallest Church in England.

Culbone, The Church of St Beuno, *c.* 1900

There is some doubt about whether this is indeed the smallest church in England (apparently it is if you go by internal area), but all authorities are agreed that it is one of the most isolated and picturesque. Guidebooks and the like suggest you walk to the church from near the village pub (The Culbone Inn) on the A39 coastal road, but I took the South West Coast Path from Porlock Weir. I walked along and up wooded coastal slopes, and even through a pair of short tunnels, which was very pleasant but seemed further than the 2 miles claimed by the sign at Porlock Weir.

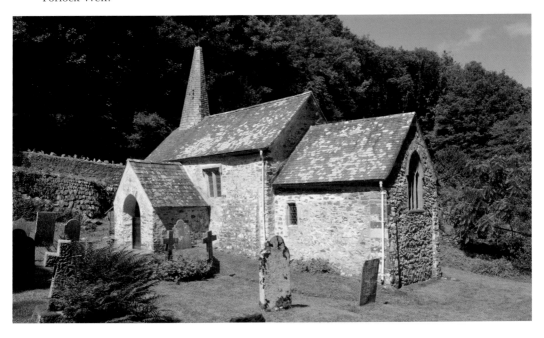

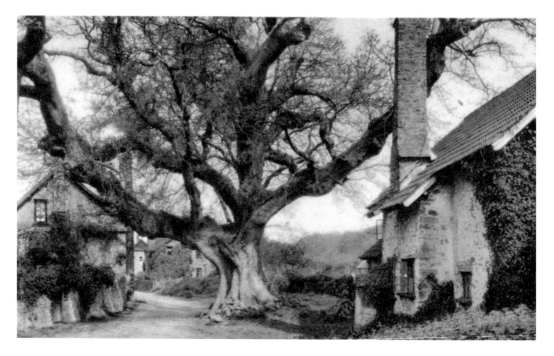

Bossington, Walnut Tree, c. 1925
A mile or so north-east of Porlock towards Bossington Hill lies the village of Bossington itself. This village is attractive both for its buildings and its setting, and it was once famed for the huge walnut tree seen in this old image. It was over 300 years old when that picture was taken, and it had to be felled around a quarter of a century afterwards.

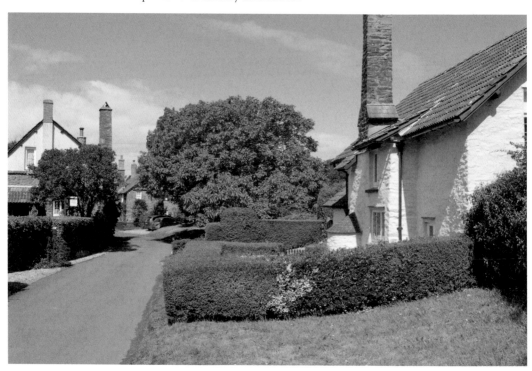

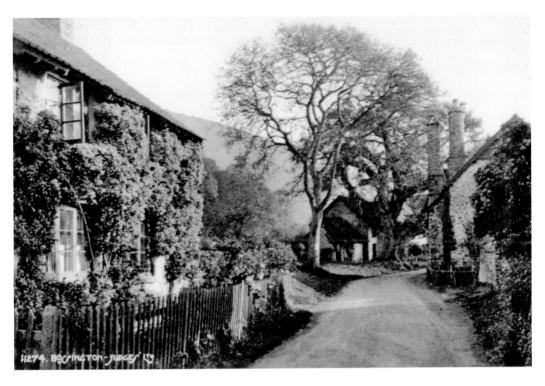

Bossington, Reverse View, *c.* 1920
The previous viewpoint was close to Bossington Green at the south-east end of the village, and we next head down the lane past the walnut tree and turn back for another view.

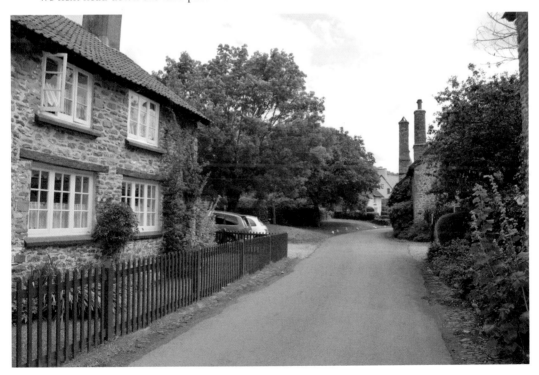

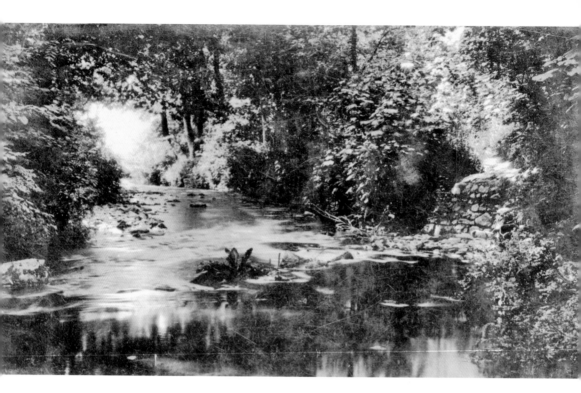

Bossington, The Horner River, c. 1925

If Bossington has a centre, it is a short distance further along where the road bends and there is a National Trust car park. A path runs next to the car park for a short distance before crossing a bridge over the Horner River and turning northward towards the coast. This route is today part of the South West Coast Path, and I believe that this old picture was taken a few dozen yards along it from the bridge.

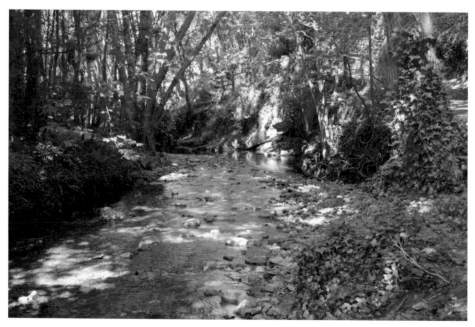

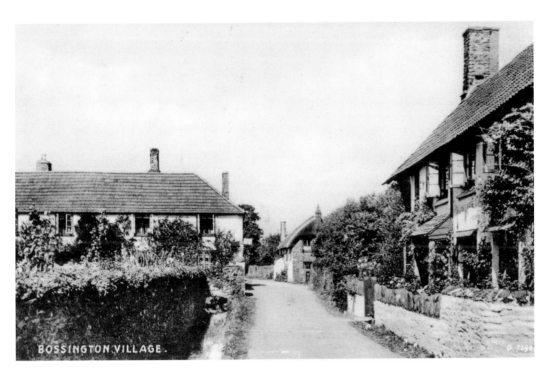

Bossington, Village Street, *c.* 1925

Going back to the lane, we go on a little further to see some of the attractive houses and cottages of the village. The house facing us on the left is Bossington Farm, and that on the right is called, nowadays at least, Banksia House.

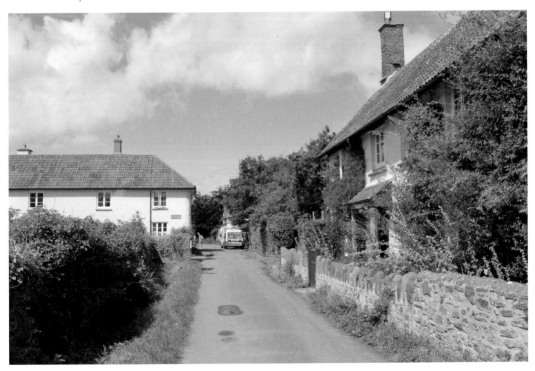

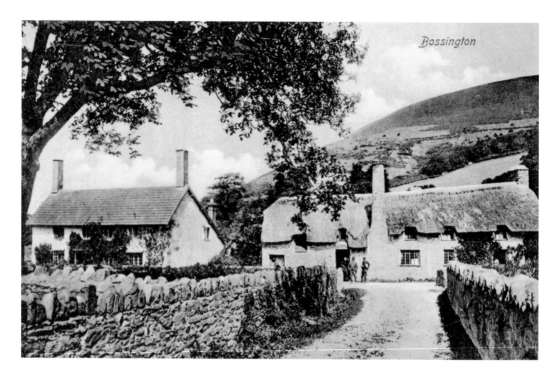

Bossington, More Cottages, *c.* 1905

At the previous viewpoint, we saw very little change between the two photographs. Now going back a short distance and around a corner (as well as some twenty years in the case of the old picture) we see a more changed view. To give them their present names, Myrtle Cottage is in the middle, Banksia House is now on the left (in the old picture at least), and Rose Cottage is on the right. Bossington Hill forms a nice backdrop.

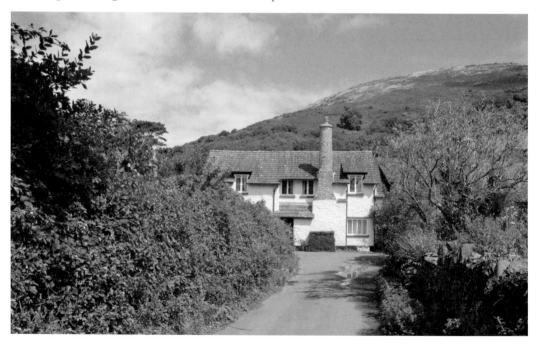

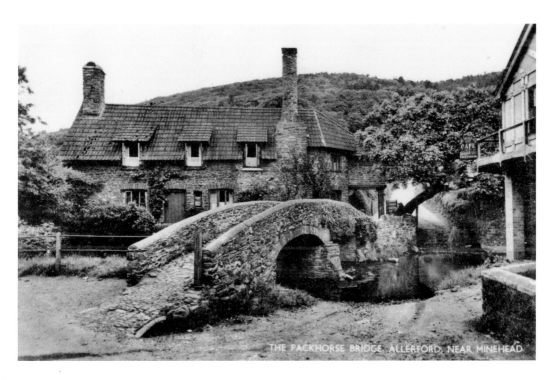

THE PACKHORSE BRIDGE, ALLERFORD, NEAR MINEHEAD

Allerford, Packhorse Bridge and More, *c*. 1930

Allerford lies about a mile south-east of Bossington by the main A39 coast road. Here we see its most picturesque location: the medieval packhorse bridge by a ford over the Aller Water, a tributary of the Horner. The sandstone bridge is an attractive sight in itself, and it is also set off well by the cottages and again Bossington Hill behind it. The building we can just see on the right is now The Pack Horse holiday apartments.

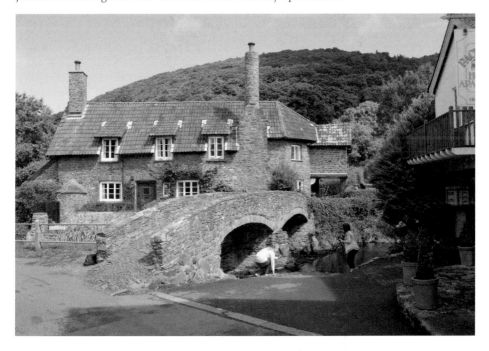

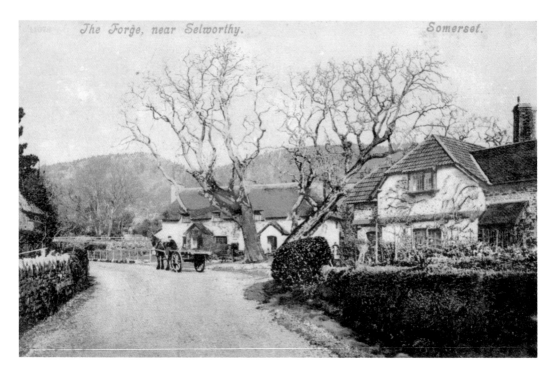

The Forge, near Selworthy. Somerset.

Selworthy, Buddle Hill, *c.* 1905

Continuing further east along the A39, we find the turn-off for Selworthy, which lies a short distance north of that road. Close to this junction, the main road originally passed through Buddle Hill, as we see in the old image, but today it goes around this quiet little hamlet.

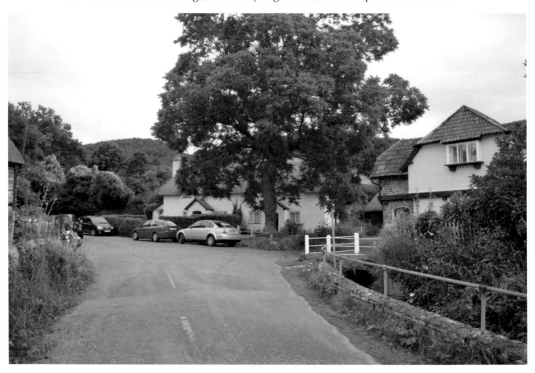

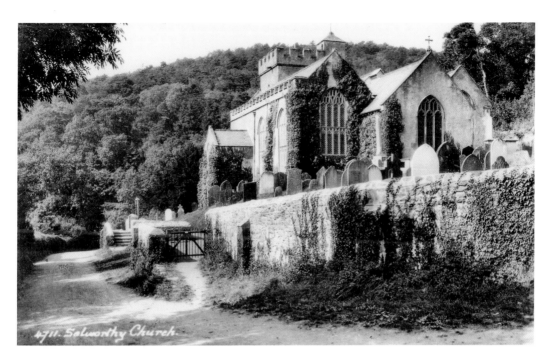

Selworthy Parish Church, c. 1935

Selworthy itself is a very pretty little village, much of it in the care of the National Trust today. Here we see the parish church, the majority of which dates from the late Middle Ages. The church has a prominent location, with views south towards Dunkery Beacon. From the viewpoint here, we can see a number of changes. A yew tree has grown into view on the right, and the entrance into the churchyard has been altered. Although it is not certain because the old picture is in black and white, the church today looks much cleaner and, perhaps unlike before, whitewashed.

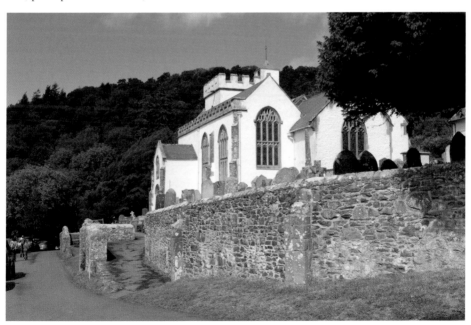

Minehead and Dunster

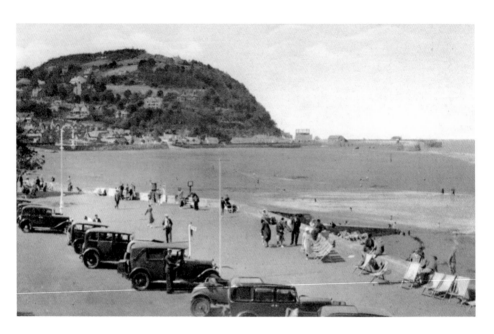

Minehead, View Towards North Hill, c. 1935
From just outside Combe Martin, the entire coast eastwards lies within the National Park until we reach the seaside resort of Minehead. Even then, the National Park includes much of the high ground around that town, and its boundary continues eastwards a little way inland for a few more miles. Here we look along the Minehead seafront to North Hill, part of which is within the National Park, and the harbour.

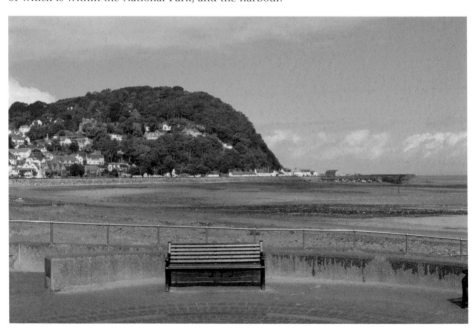

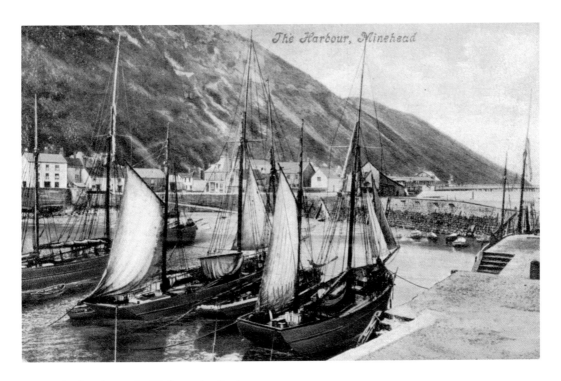

The Harbour, Minehead

Minehead, North Hill from the Harbour, *c.* 1900

We head across to the harbour for these scenic views from the outer wall. The further slopes of North Hill as seen here are within the National Park today and, comparing the two views, we see a massive increase in tree cover. The older view has been coloured artificially, but even then it is clear that there are few trees. In the same view, we see the lines of two tracks that run around the hillside.

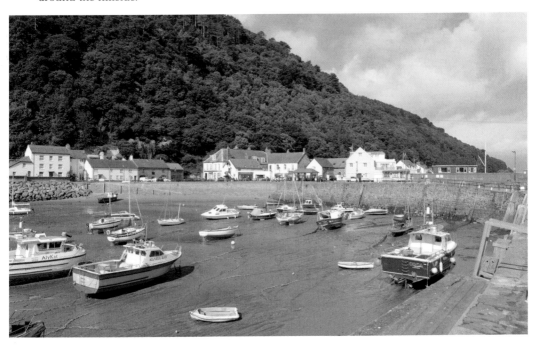

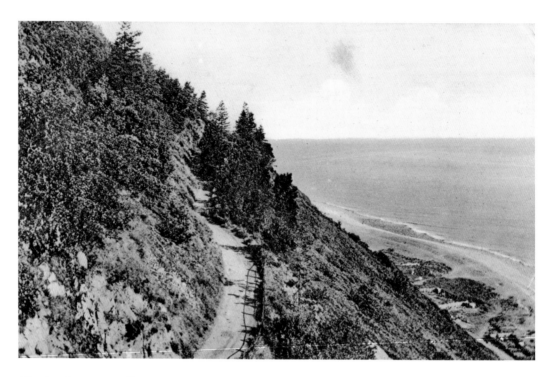

Minehead, Court Walk, *c.* 1930
We now go up the hillside to the higher of those two tracks, which once bore the rather grand name of Court Walk, to get an even better idea of the tree growth. The old shot was taken about thirty years after the previous old view, and shows a scattering of trees, which look self-seeded.

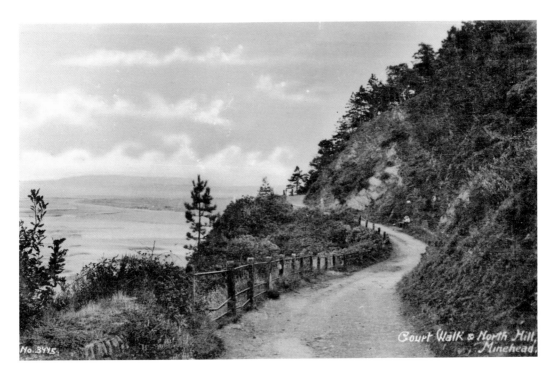

No. 3445.

Court Walk & North Hill, Minehead.

Minehead, Reverse View, c. 1920

Next, a view in the opposite direction on the same track. Here and in the last instance, the railing beside the track helped me to identify the location from which the old picture was taken. Today, this section of track is on the boundary of the National Park, and we have lost the view to Warren Point beyond Minehead and the seaward end of the Quantock Hills that we see in the old image.

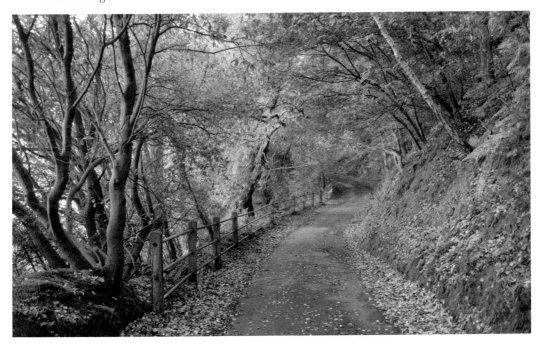

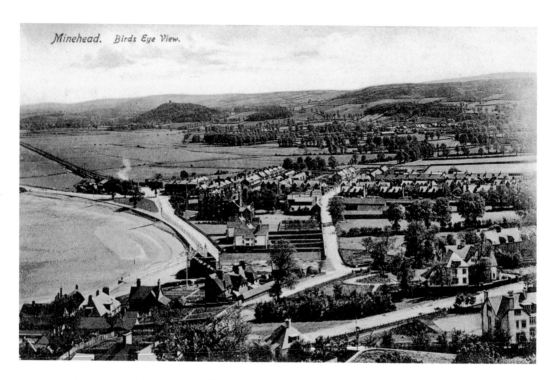

Minehead. Birds Eye View.

Minehead, View From North Hill, *c.* 1900

Going back around to the eastern slopes of North Hill, we get a view across Minehead and along the hills that form the edge of the National Park. In the foreground of the old photograph, we see the expanding suburbs of Minehead, which today cover much of the hillside. The railway line comes into the town from the left, and a puff of smoke must be coming from a steam train at the station. The prominent, isolated hill in the background is Coneygar Hill by Dunster (on which Coneygar Tower can be made out).

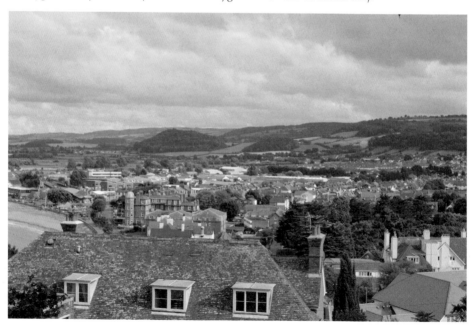

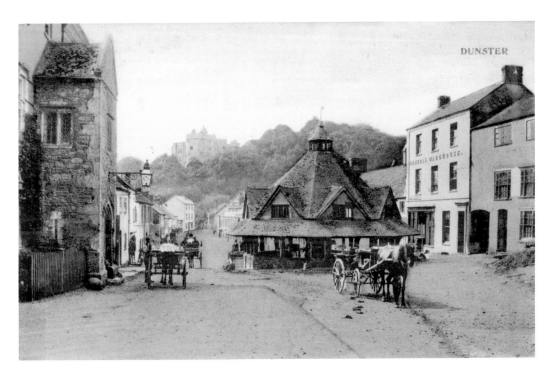

Dunster, The Centre, *c.* 1900

Back into the National Park and over to Dunster for a southward view down the main street that captures some of its many historic features. The castle on the hill in the distance belonged to the Luttrell family from 1376, one of whom built the Yarn Market in the marketplace, which is the octagonal structure we see on the right. Many village pubs around the country bore the name of the local landholding family, and here we also see the 500-year-old Luttrell Arms on the left.

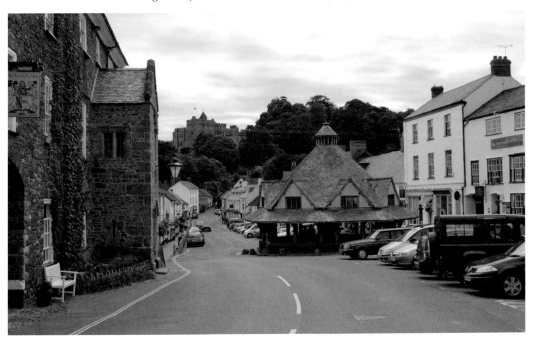

73

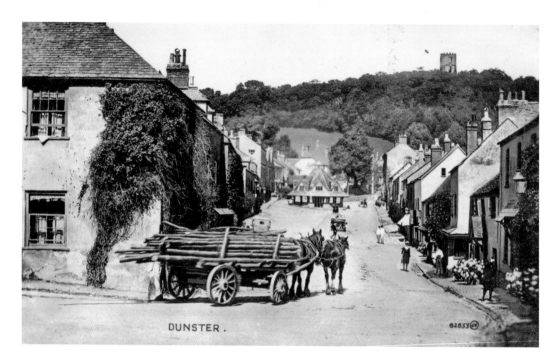

Dunster, High Street, *c.* 1925

We now go to the other end of the High Street and turn around for a reverse view. Comparing these two photographs illustrates not just social changes such as the greater use of cars, but also the greatly increased popularity of Dunster as a visitor attraction. Again, the Yarn Market is prominent in this view. Its exact date of construction seems uncertain (the range of possible dates covers a decade or so either side of 1600), but it is known for certain that it was restored in 1647, because this is stated on an inscription that it bears.

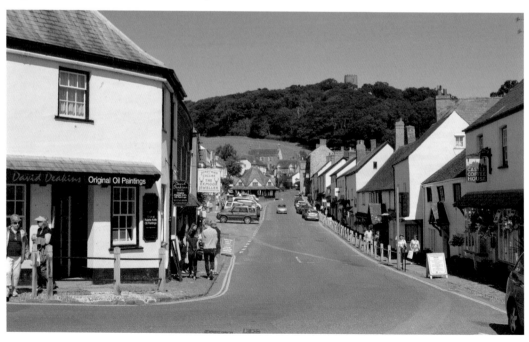

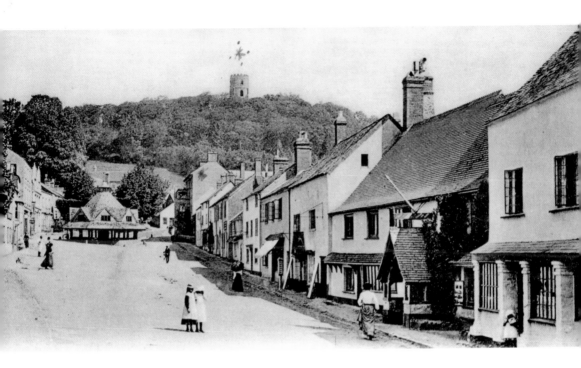

Dunster, Conygar Tower, c. 1905

Another old view of the High Street, this one a little older, gives a good view of Conygar Tower on the hill of the same name. It is a circular, three-storey structure of sandstone, built in 1775 as a folly and landmark by the Luttrells of Dunster Castle. Tree growth means that there is one less window visible in my photograph!

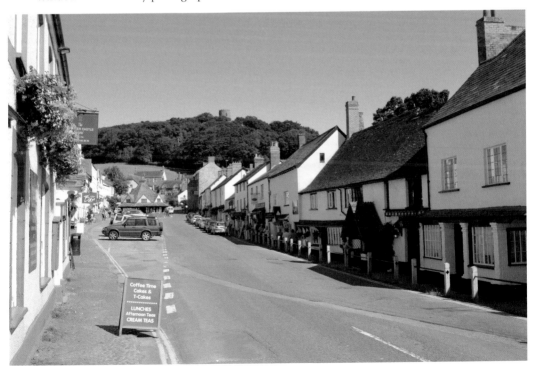

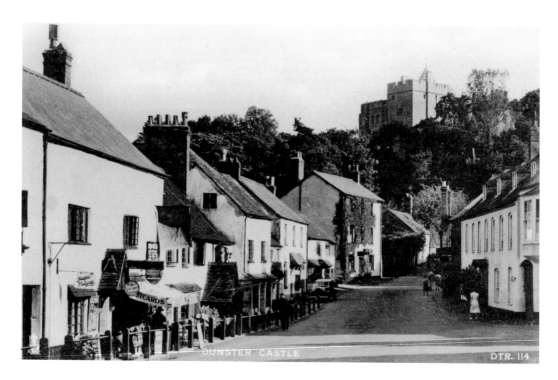

Dunster, View to the Castle, c. 1930

Heading a short distance along the High Street, we turn around and look up Castle Hill towards Dunster Castle. Nothing now remains aboveground of the original Norman castle, built by William de Mohun in the late eleventh century. The earliest surviving structures are the thirteenth-century gatehouse and gateway, while the present castle itself was built from 1617 onwards by William Arnold for the Luttrell family. The castle is now in the care of the National Trust.

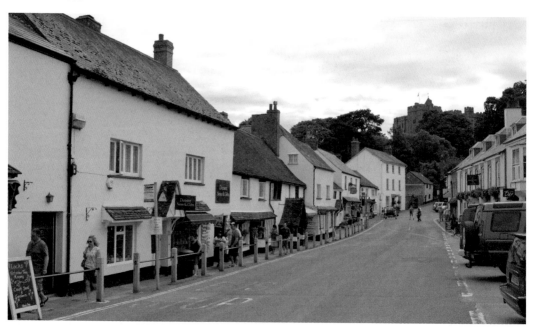

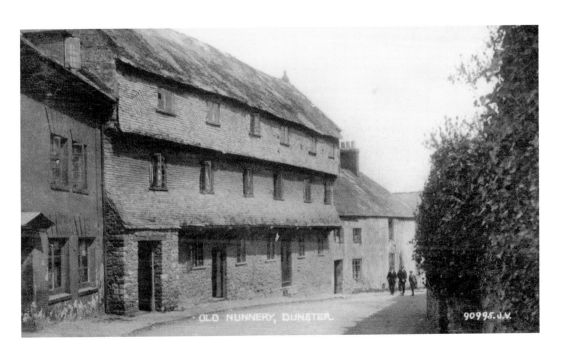

Dunster, The Nunnery, *c. 1910*

The main route through the village bends round to the right, as seen in the previous view, and becomes Church Street. Here we see this extraordinary building, a terrace of three cottages that is three storeys high and timber-framed, with the upper storeys overhanging and hung with tiles. It dates from the fifteenth or maybe even the fourteenth century, and was probably associated with Dunster Priory. The name Nunnery is a Victorian invention.

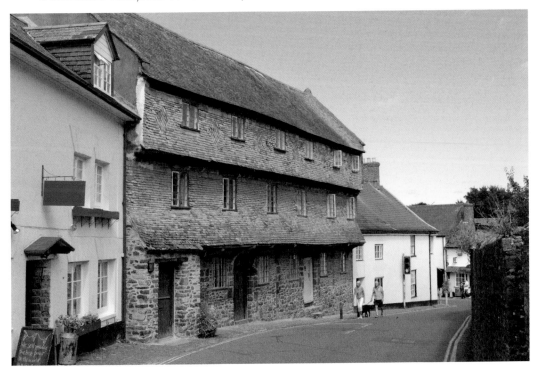

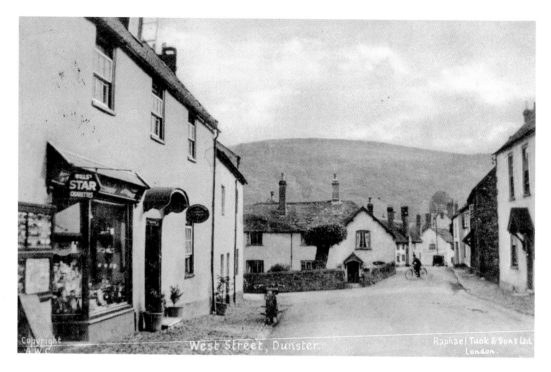

Dunster, West Street, c. 1930

Church Street then turns a corner and becomes West Street, and a short way along we find our next location. The gap between the properties on the left is the start of Mill Lane, and to the right of that is the bridge over the Mill Stream, which is being crossed by a cyclist in the old shot.

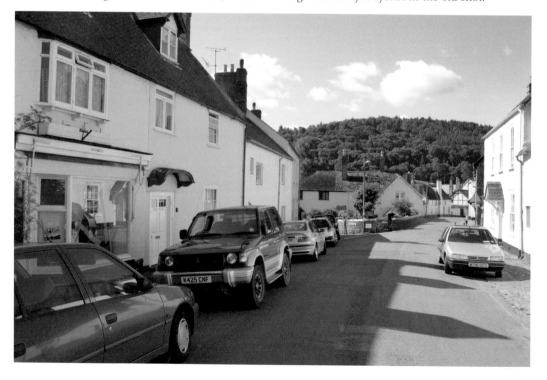

Dunster, Park Street, c. 1925

A little further on still we come across Park Street, which runs roughly parallel with Mill Lane and was so named presumably because it ran towards a deer park. Down here, we find this delightful group of seventeenth-century cottages, little changed over the past century.

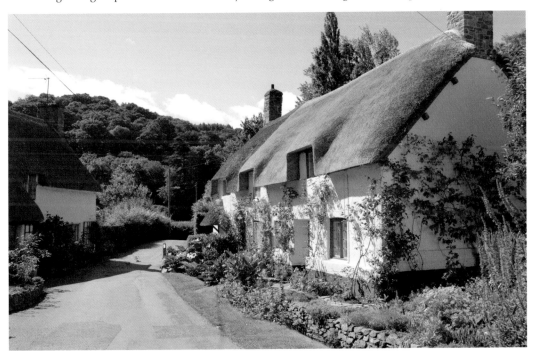

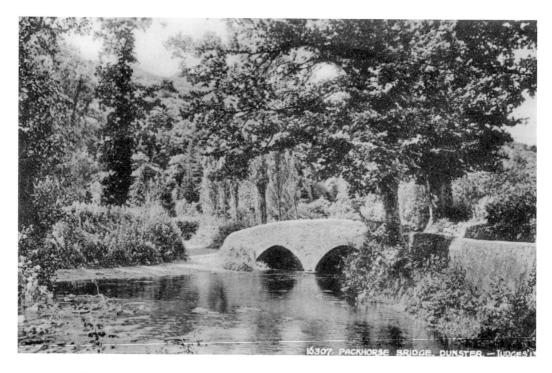

16307. PACKHORSE BRIDGE. DUNSTER. —[JUDGES']

Dunster, Gallox Bridge, *c.* 1925

Park Street leads down to a crossing of the River Avill. Here we find Gallox Bridge, a fifteenth-century stone packhorse bridge. A line of horses only needs a narrow bridge such as this, but vehicles have always needed something wider, and there is also a ford here.

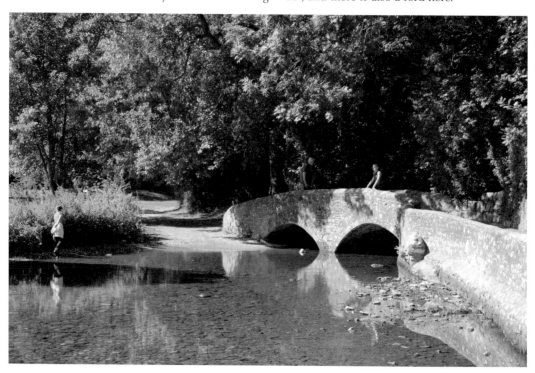

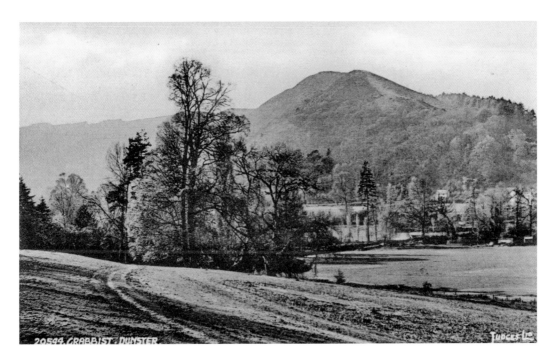

Dunster, View to Grabbist Hill, *c.* **1925**

Several footpaths head off from the other side of Gallox Bridge. I took the one that heads east along a hillside, through what was once the Luttrell family's deer park, towards Carhampton to get this next shot, although I think the old photographer stood a little further downslope. The view looks back to the north-east across the southern end of Dunster village to Grabbist Hill, where once again we see changes in tree cover. In the old picture, trees already cover the lower slopes of the hill, while there may be recent planting higher up. Today, the whole hill is covered.

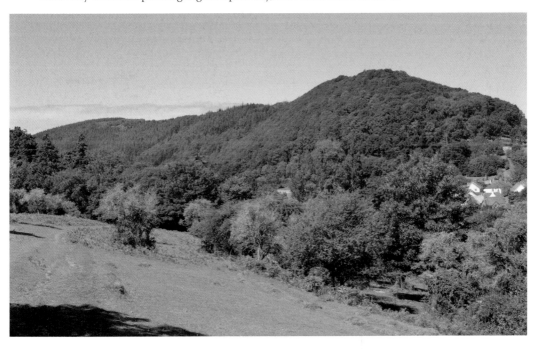

Central Exmoor

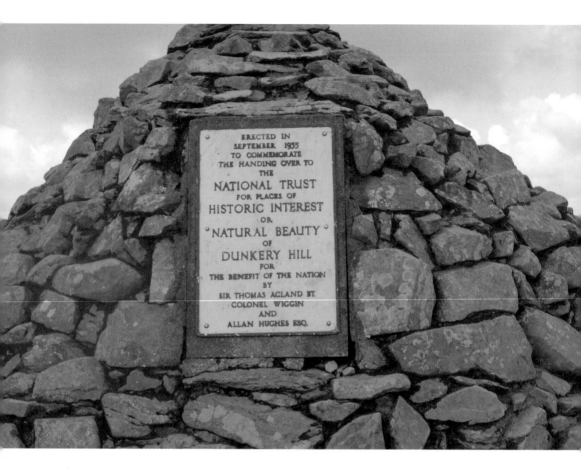

ERECTED IN
SEPTEMBER 1935
TO COMMEMORATE
THE HANDING OVER TO
THE
NATIONAL TRUST
FOR PLACES OF
HISTORIC INTEREST
OR
NATURAL BEAUTY
OF
DUNKERY HILL
FOR
THE BENEFIT OF THE NATION
BY
SIR THOMAS ACLAND BT.
COLONEL WIGGIN
AND
ALLAN HUGHES ESQ.

Dunkery Beacon, c. 1910
We start this chapter some 4 miles south of Porlock, and encounter something of a mystery. At 1,075 feet above sea level, Dunkery Beacon is the highest point not only on Dunkery Hill but also in the whole of Exmoor and Somerset. Its prominence was recognised over 3,000 years ago in the Bronze Age, when a number of barrows or burial mounds were constructed here. In 1935, a cairn was erected here to commemorate the donation of the estate that included Dunkery Hill by Sir Thomas Acland to the National Trust. The old picture must show the predecessor of this cairn – it looks like the traditional rough pile of stones left individually by walkers. My photographs show the 1935 cairn, which sits atop one of the Bronze Age barrows, and its commemorative plaque, while the old image seems to show its cairn in a more level spot, so I am not certain exactly where it was located.

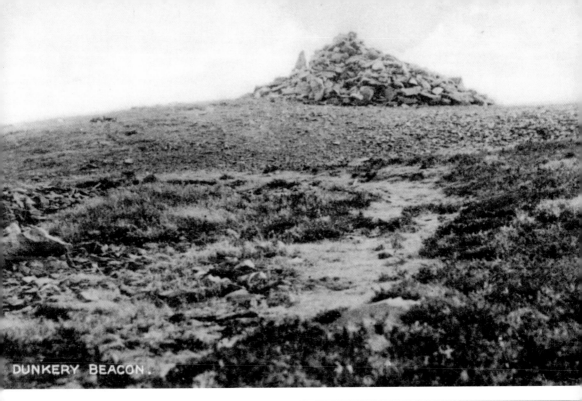

DUNKERY BEACON.

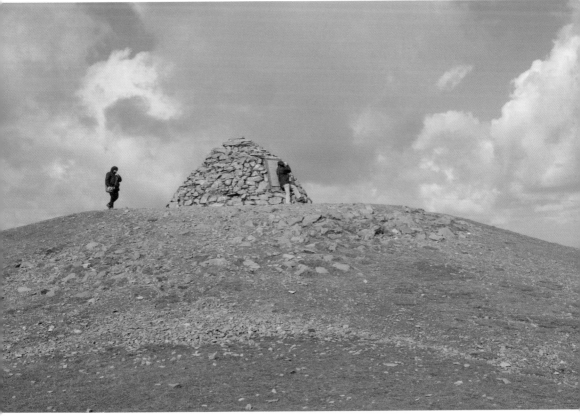

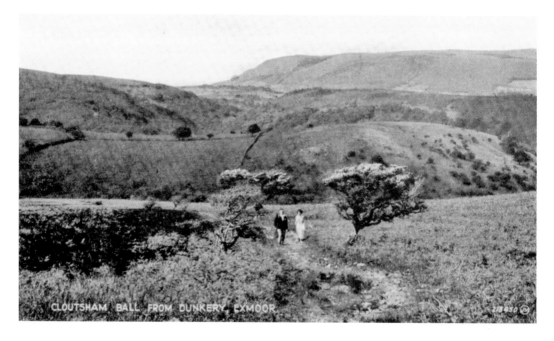

CLOUTSHAM BALL FROM DUNKERY EXMOOR

Dunkery Hill, The View North, *c.* 1930

The old photograph here shows the view from a path that runs down the north side of Dunkery Hill from the Beacon. In the middle distance, we see the gap in a ridge cut by the Horner River, with Horner Wood to its left. Beyond is Bossington Hill on the coast. My shot was taken from further uphill, so that you can see Cloutsham Farm below Horner Wood. The Welsh coast can also be made out across the Bristol Channel.

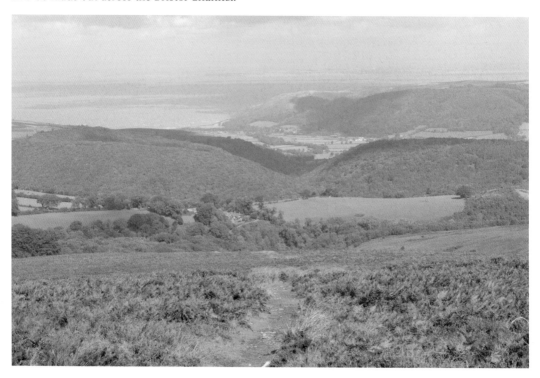

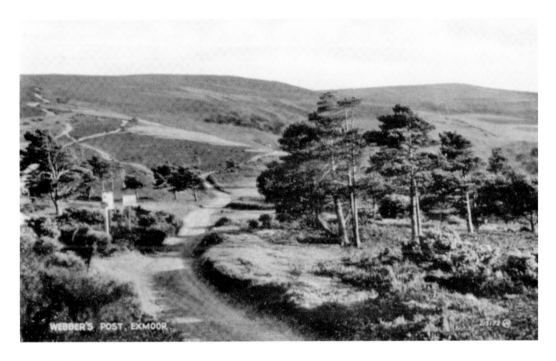

Webbers Post, c. 1925

A couple of miles north-east of Dunkery Beacon, we find the junction of three roads at Webbers Post. With the increase in tourism and car usage during the twentieth century, Webbers Post went from an isolated junction on the high moorland to a spot frequented by visitors who stopped to admire the views. The old photograph shows it early on in this process and little changed. I may not have found the exact spot from which it was taken, but my shot shows the improvement in the roads as well as the increased vegetation cover hereabouts.

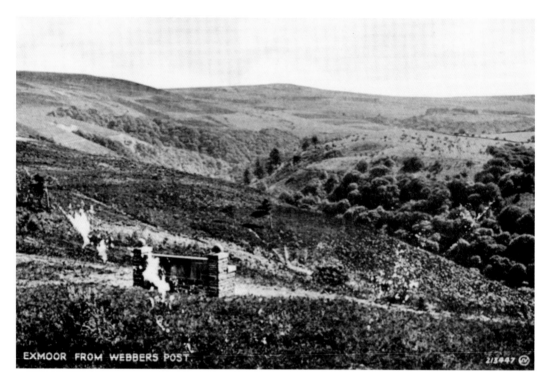

EXMOOR FROM WEBBERS POST

The View from Webbers Post, *c.* 1925

And here is an illustration of what people were coming to see – the view south-west towards Dunkery Beacon. When the old picture was taken, there was already a seat for visitors; today, there are also a large car park and on-site interpretation.

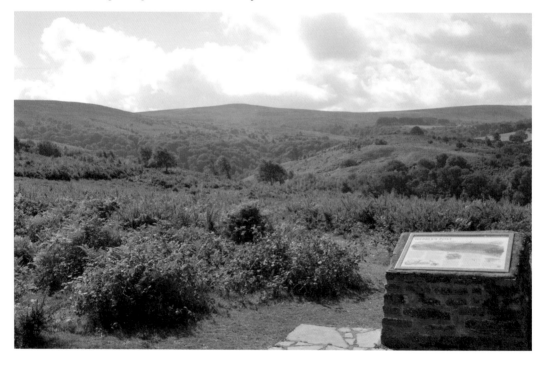

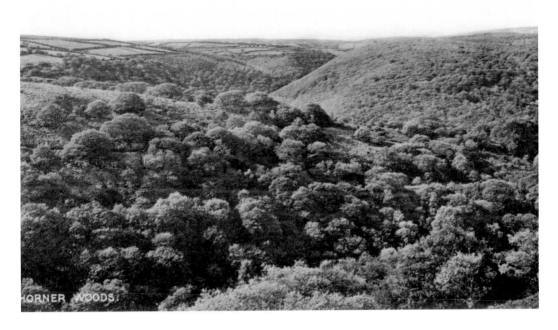

HORNER WOODS.

Horner Wood, *c.* 1920

To further illustrate the point about the stunning view, we follow the road that runs south-west from Webbers Post a short distance, and look westward from the hillside just below towards Horner Wood. Today, this ancient woodland is part of a National Nature Reserve.

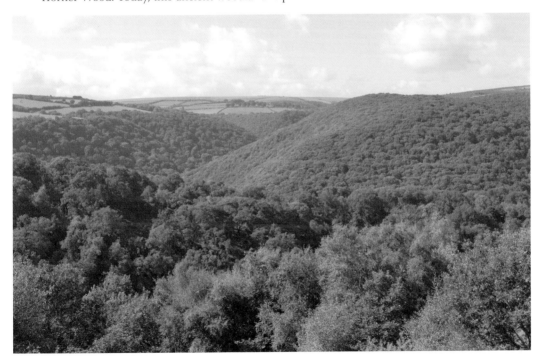

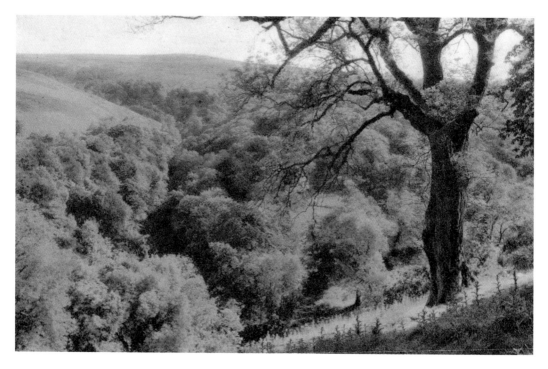

Cloutsham Farm, View to Dunkery Hill, *c.* 1935
And here is a reverse view of one we saw a few pages back – we have followed that road round to Cloutsham Farm and are looking south towards Dunkery Hill. As we would probably hope, not a great deal has changed over the past eighty years, although I think the tree cover on the lower slopes is a little denser.

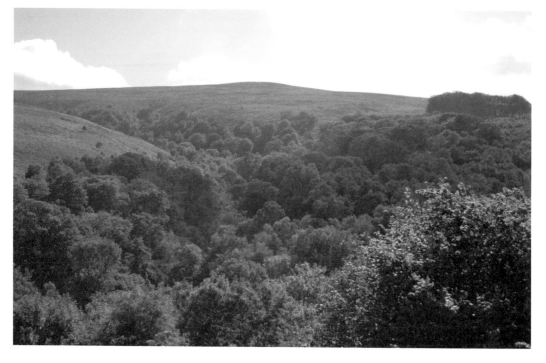

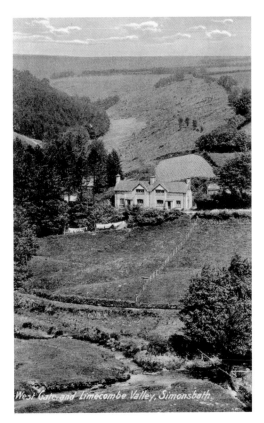

West Gate and Limecombe Valley, Simonsbath.

Simonsbath, Cottages and Confluence, *c.* 1930

Simonsbath lies some 8 miles to the south-west of Cloutsham Farm, in a particularly isolated part of Exmoor. Here we are on the road that heads south-west out of the village to South Molton, looking across to cottages on the Challacombe and Barnstaple Road. The cottages have been terraced into the hillside, and in the old photograph there is a little field behind them, perhaps where the cottage dwellers grew their own produce. In the foreground, we see the spot where the Bale Water and Cornham Brake flow together to form the River Barle, a tributary of the Exe.

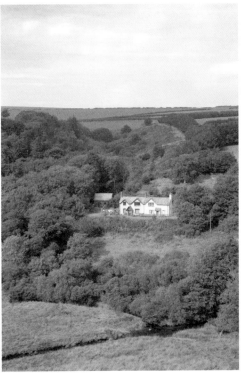

The South

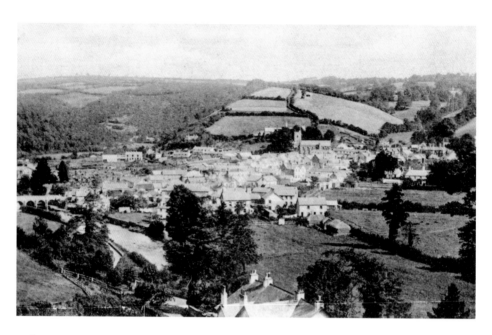

Dulverton, View from the South-West, c. 1910

We start this chapter close to the southern boundary of the National Park. Officially, Dulverton is one of the National Park's two towns (the other being the linked Lynton and Lynmouth), although many villages in this country have a higher population than its 1,500. The viewpoint is on Andrew's Hill, and in the old view we see the town's bridge to the left and the parish church over to the right. The view today is largely obscured by trees, so please take my word that the town has spread out somewhat over the past century.

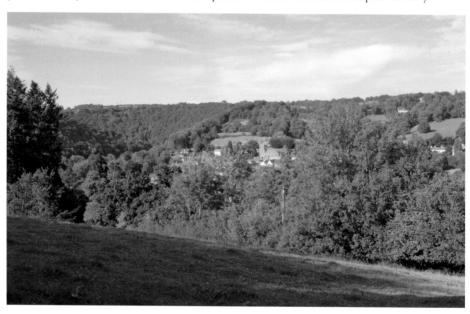

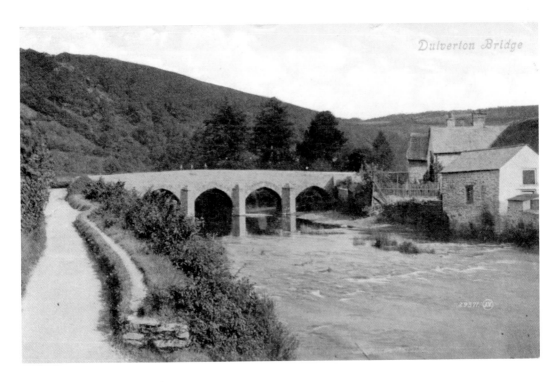

Dulverton, Barle Bridge, *c.* 1905

We head down for a look at one of Dulverton's iconic sights: the medieval five-span bridge that crosses the River Barle, which is now not far from its confluence with the Exe. The town grew up in this location precisely because it was possible to cross the Barle here, and the fact that part of the name Dulverton means 'ford' in old English explains how people got across before the bridge was built.

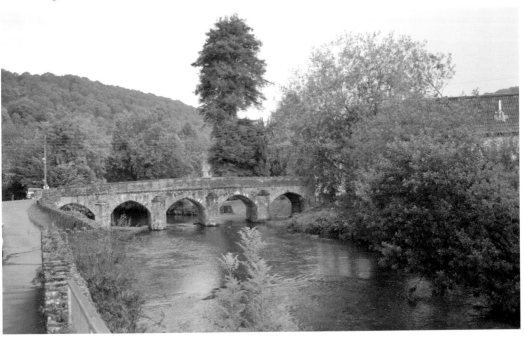

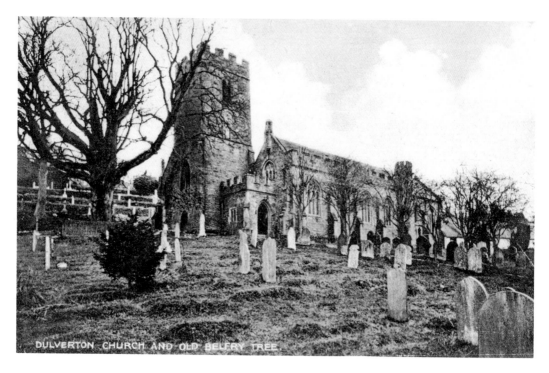

DULVERTON CHURCH AND OLD BELFRY TREE

Dulverton Parish Church and Belfry Tree, c. 1925

Now we go up through the town centre to have a look at the church, which is dedicated to All Saints. The tower dates from the thirteenth century, and to its left in the old picture there is the Belfry Tree, a giant sycamore that was higher than the tower and was just as much of a local landmark (you can see it in the previous old photograph but one). Today, there is only a small mound that marks the spot where the tree grew.

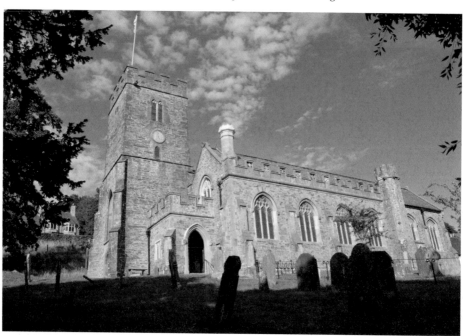

Dulverton, Northmoor Road, *c.* 1900

This old picture mystified me for quite a while. It shows Northmoor Road, which runs roughly north out of Dulverton alongside the River Barle. Today, no group of houses matches those it depicts, but after some exploring I decided it must have been taken from a public footpath that heads north-east and uphill from the road almost half a mile from the town centre, and must show an area marked on the maps as Weir Cleeve, where the road bends round to the north-west. But you might disagree!

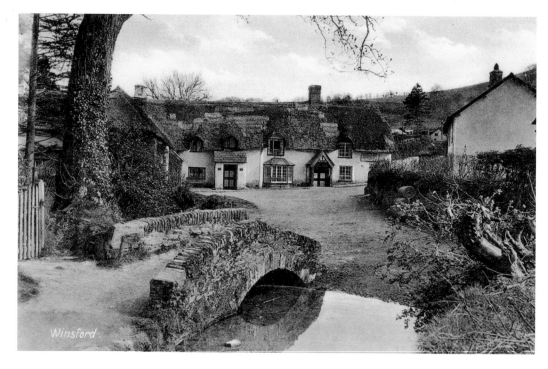

Winsford, Packhorse Bridge and Pub, *c.* 1920

The village of Winsford lies about 5 miles north of Dulverton as the crow flies, and the River Exe flows around it. Here we look across a medieval packhorse bridge that crosses a tributary stream of that river towards the Royal Oak Inn, which itself dates from the sixteenth century. The bank on the near side of the stream looks to have been built up since the old photograph was taken, presumably to prevent flooding.

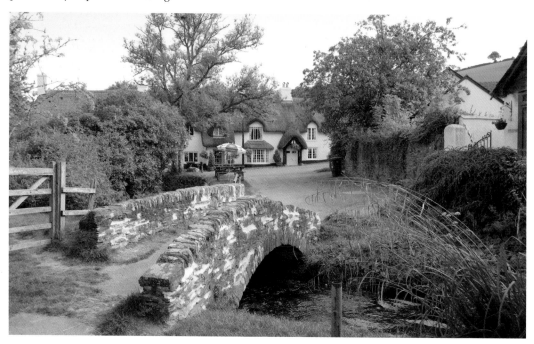

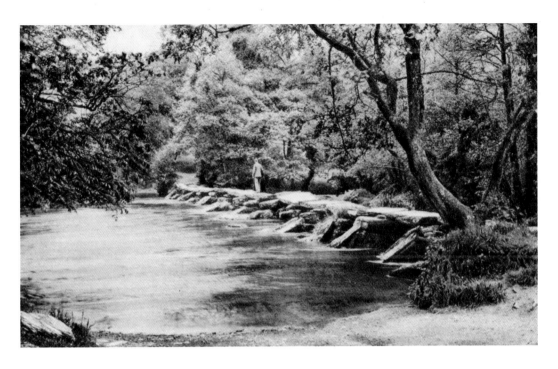

Tarr Steps, *c.* 1925

Now for another type of bridge: Tarr Steps is a clapper bridge, a stone structure found in Exmoor, Dartmoor and other upland areas of Britain. It crosses the River Barle in quite a remote location about 4 miles north-west of Dulverton. A lane leads to it off the B3223 that runs north-west from Dulverton, passing through the hamlet of Liscombe. Most of the traffic that comes down this lane these days brings visitors to the bridge.

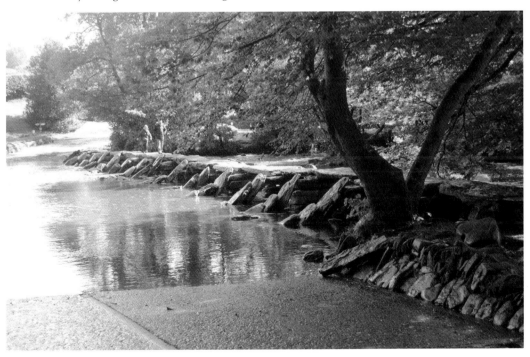

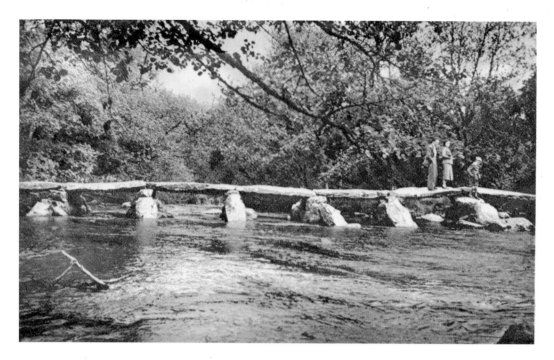

Tarr Steps, Side View, *c.* 1935

Looking side-on helps us to see how the bridge was constructed. Stone piers were built on the riverbed and large flat slabs of sandstone were laid between them. Such construction is liable to be damaged by floodwaters, and this has happened several times in living memory, most recently in December 2012, after which half the stonework had to be put back in place. There is no way of dating clapper bridges accurately – Tarr Steps is thought most likely to date from the Middle Ages, but it could be up to 3,000 years old.

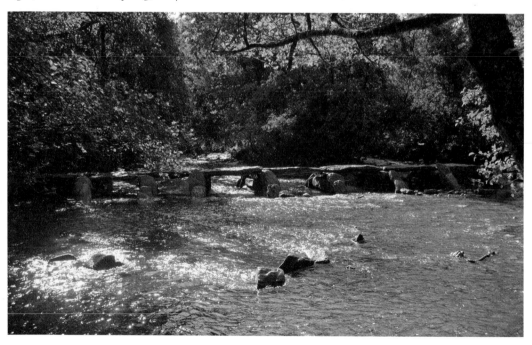